The Heart of Coloring

XIXI WANG

The Heart of Coloring: An Anatomical Heart-Themed Coloring Book
Copyright © 2018 Xixi Wang
Cover art by Xixi Wang

All rights reserved. Except for brief passages quoted in newspaper, magazine, radio, television, or online reviews, no portion of this book may be reproduced, distributed, or transmitted in any form or by any means, electronic or mechanical, including photocopying, recording, or information storage or retrieval system, without the prior written permission of the publisher.

ISBN: 1537075608
ISBN-13: 978-1537075600

First printing April 2018

This book belongs to

ART SAVES LIVES.

ABOUT ART START

Art Start is a nonprofit organization transforming the lives of underserved youth in New York City through daily creative arts workshops. Their kids live in shelters, on the streets, or are involved in court cases. While collaborating with teaching artists, educators, and volunteers, the youth are able to pursue meaningful opportunities against all odds. To learn more, visit www.art-start.org.

100% of proceeds from the sale of this book will go to Art Start.

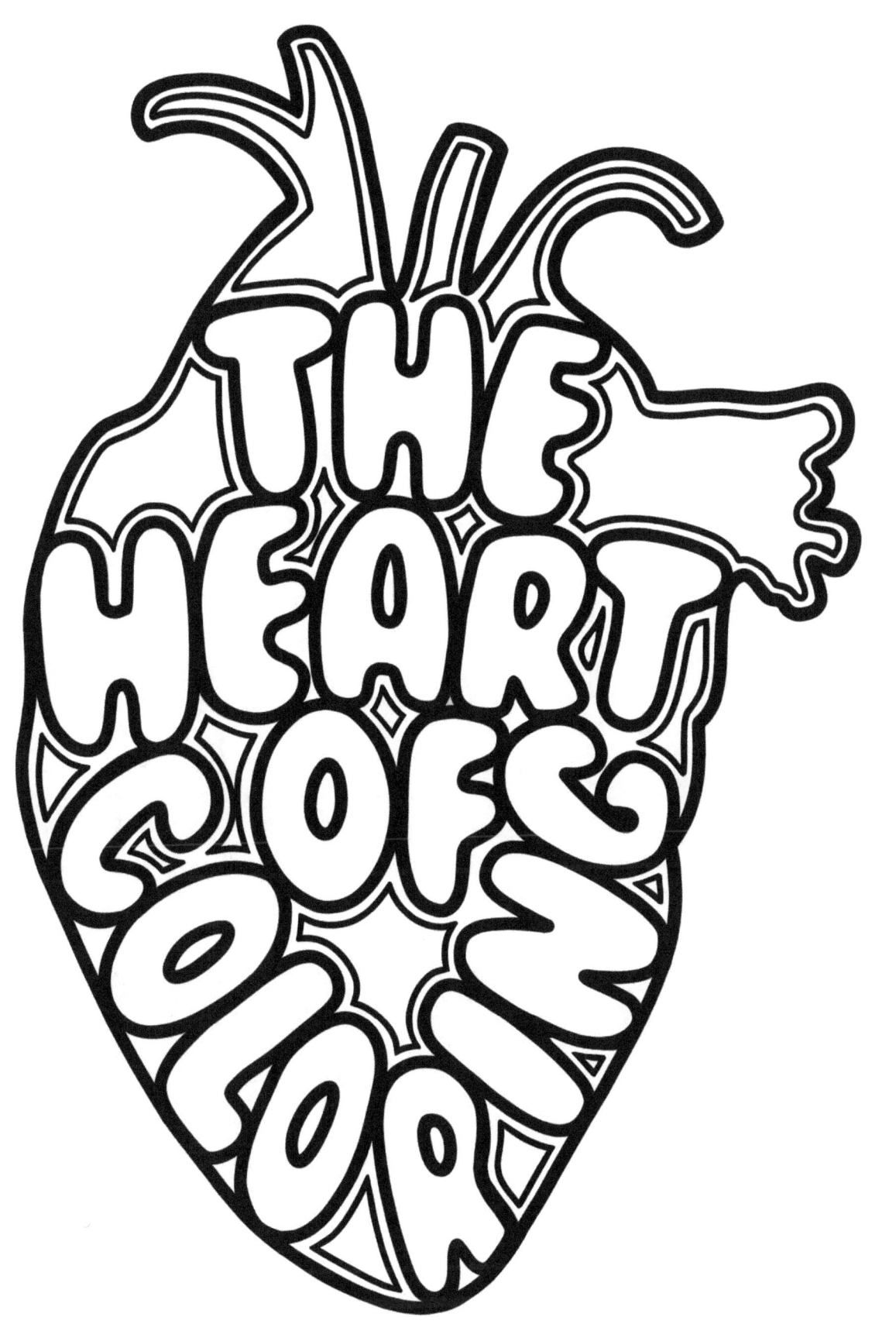

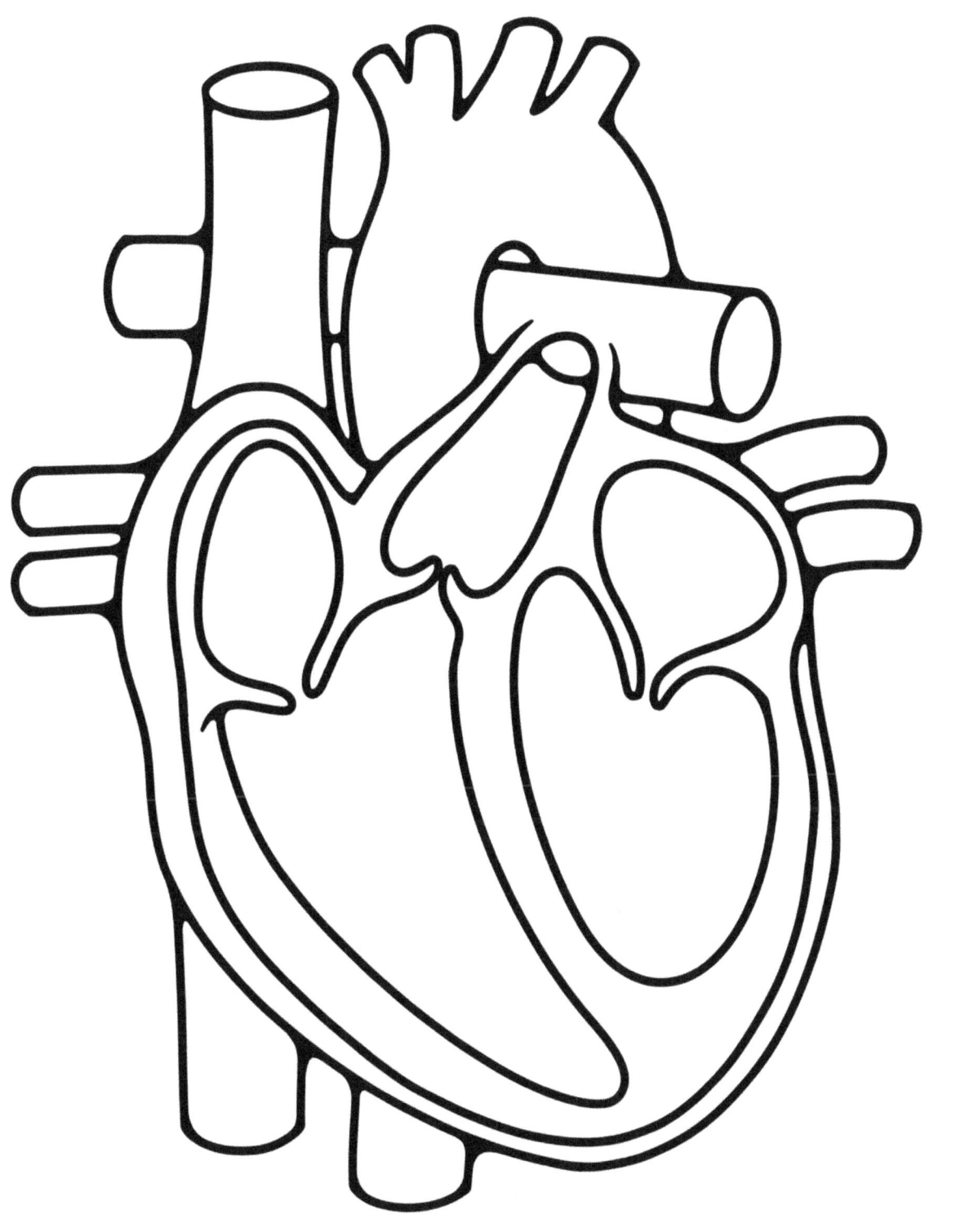

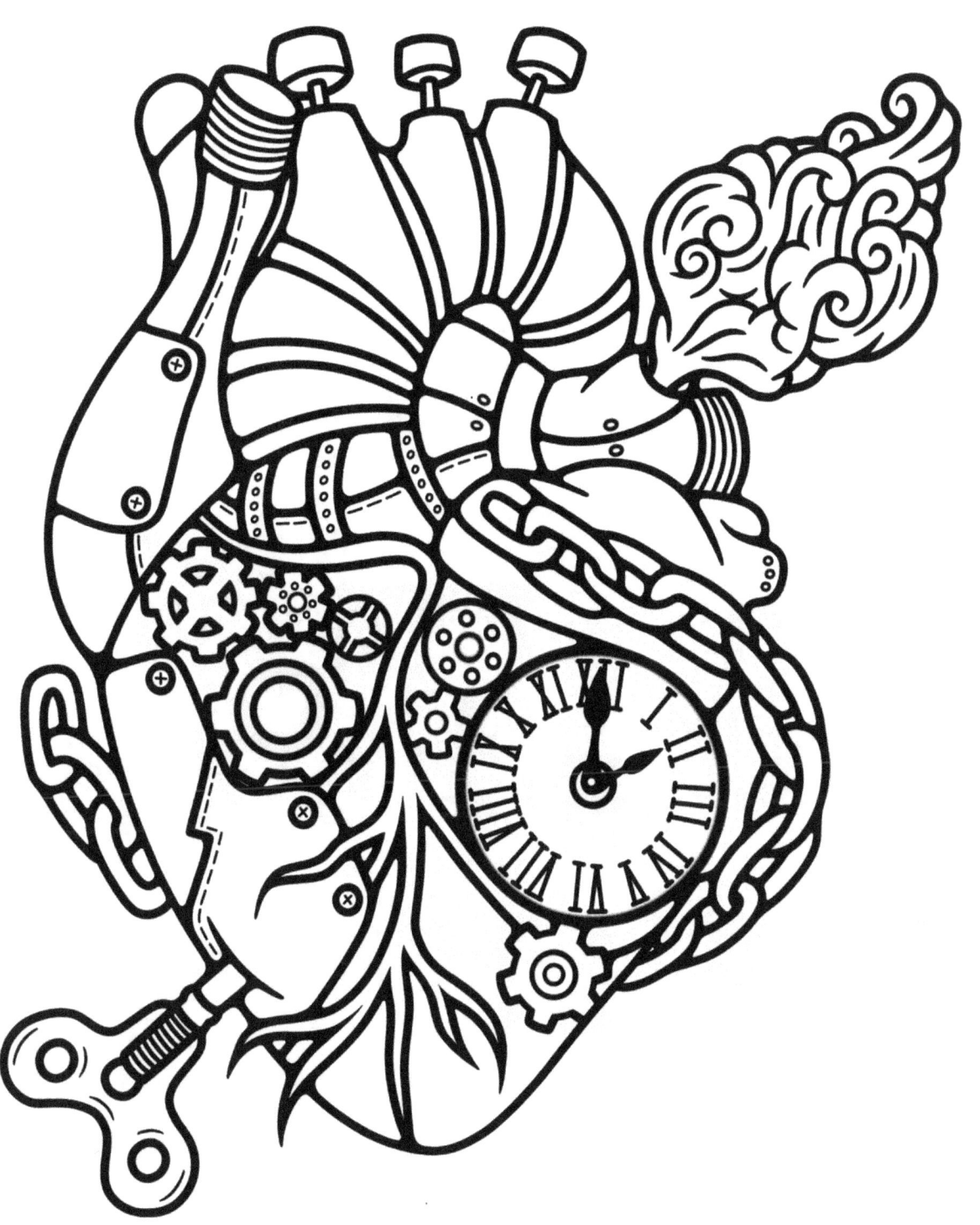

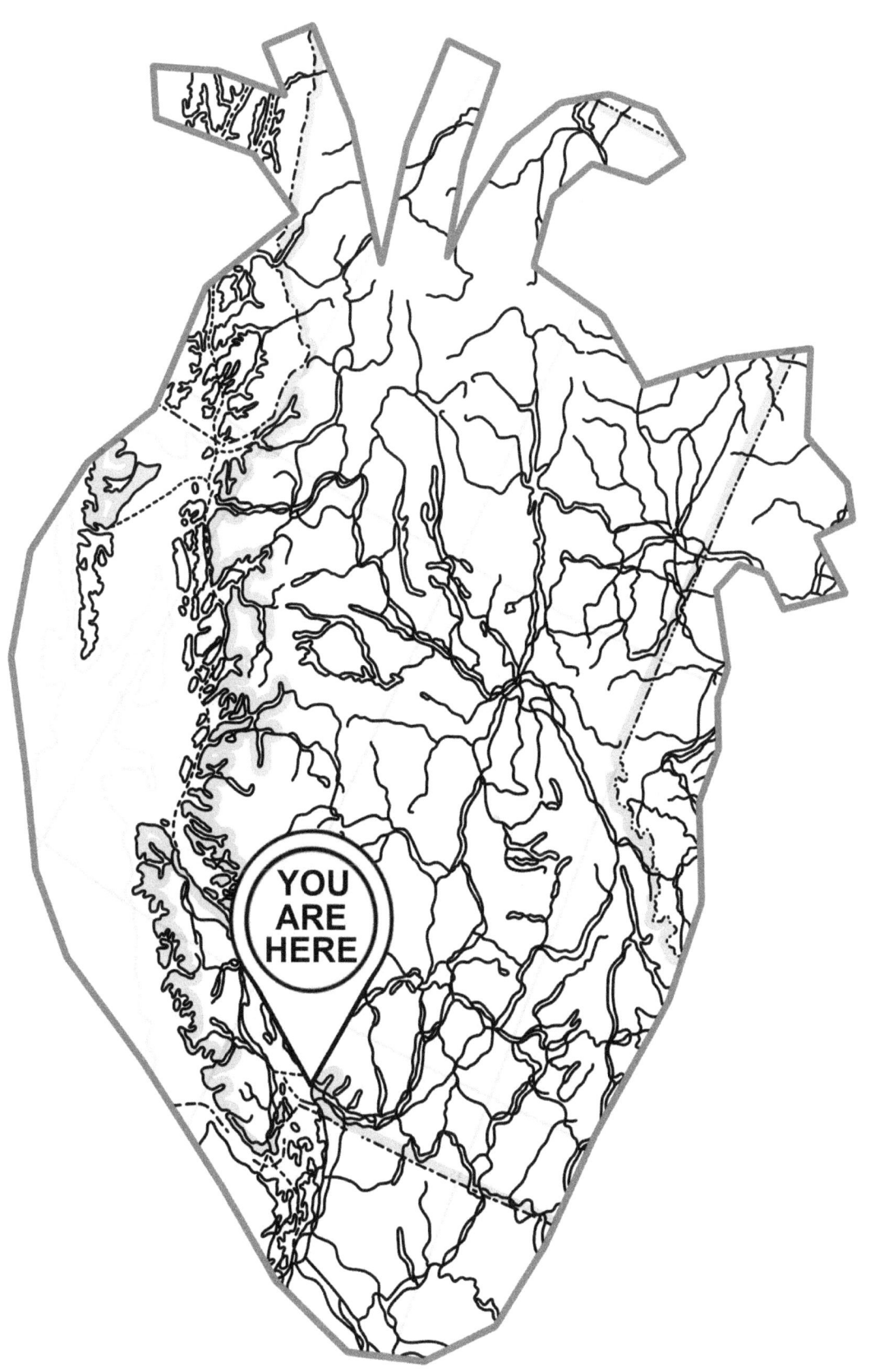

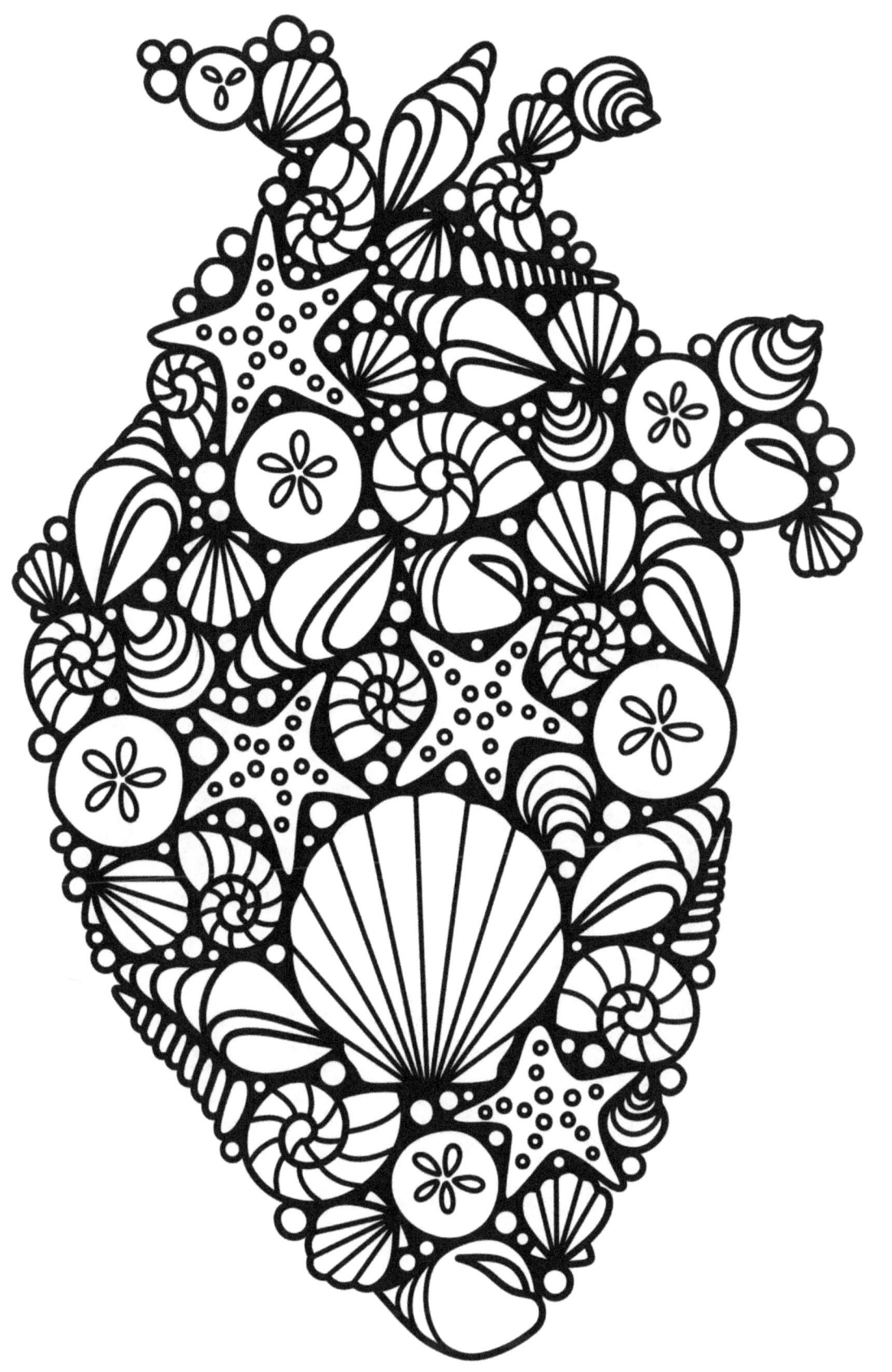

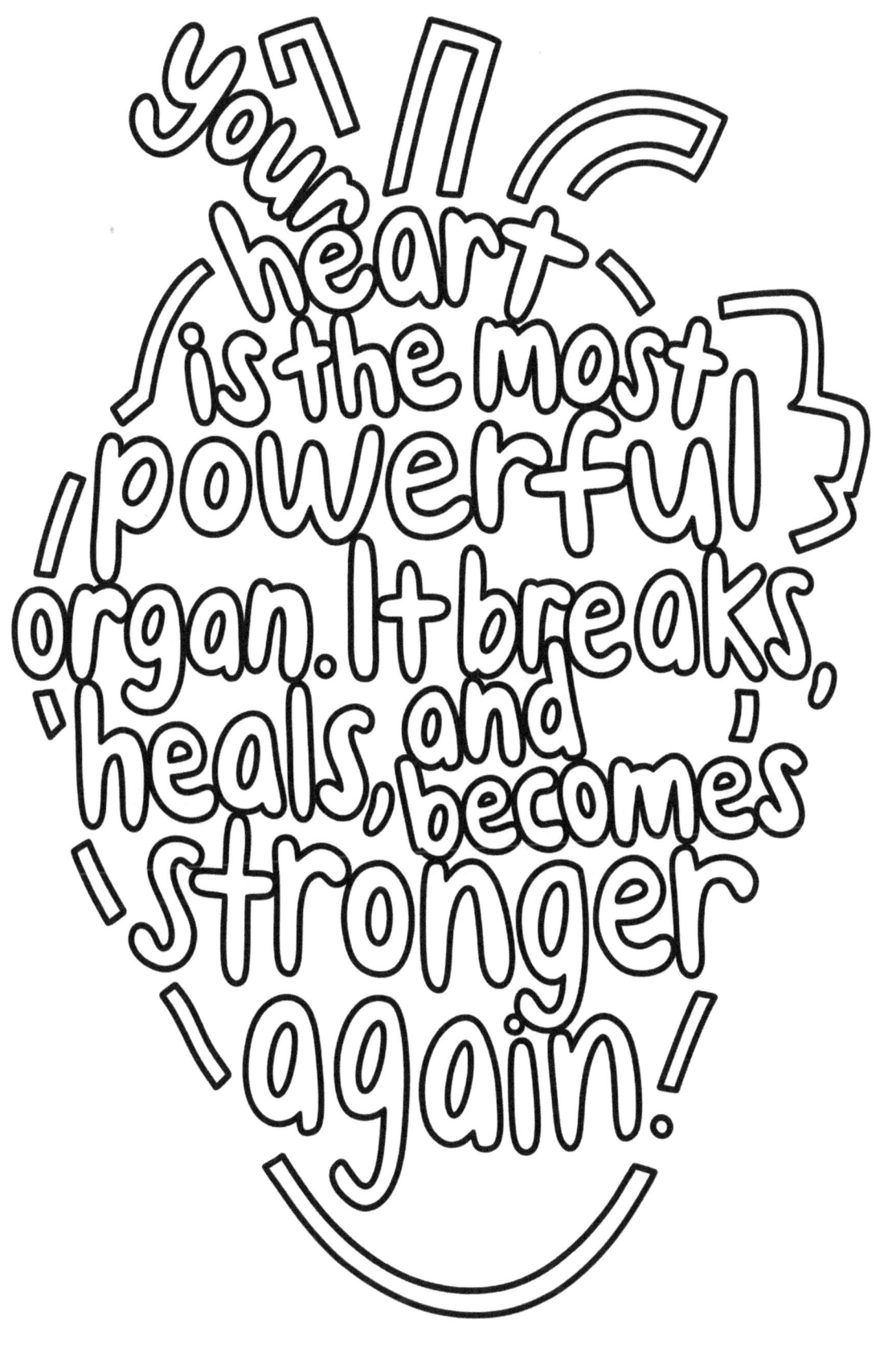

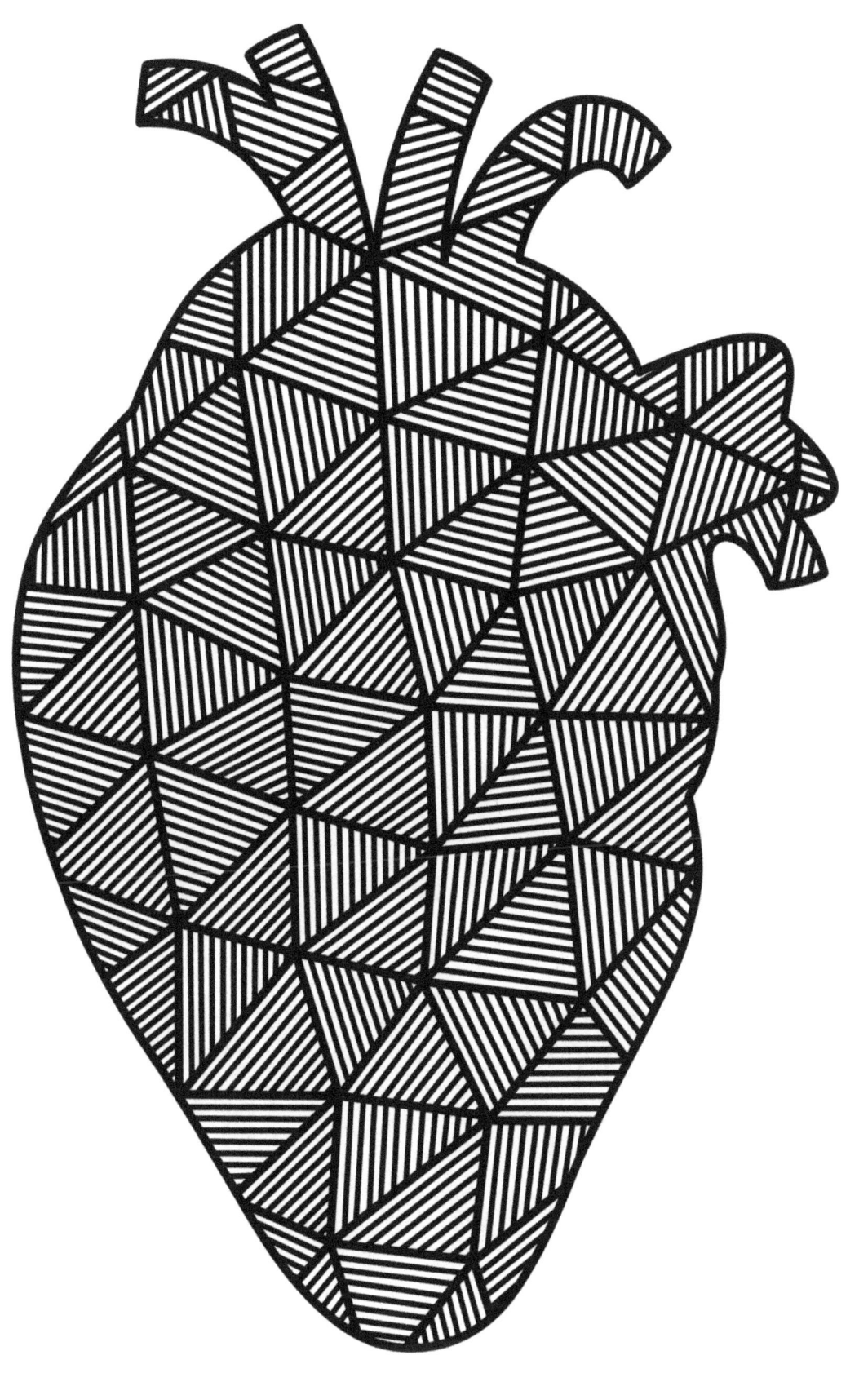

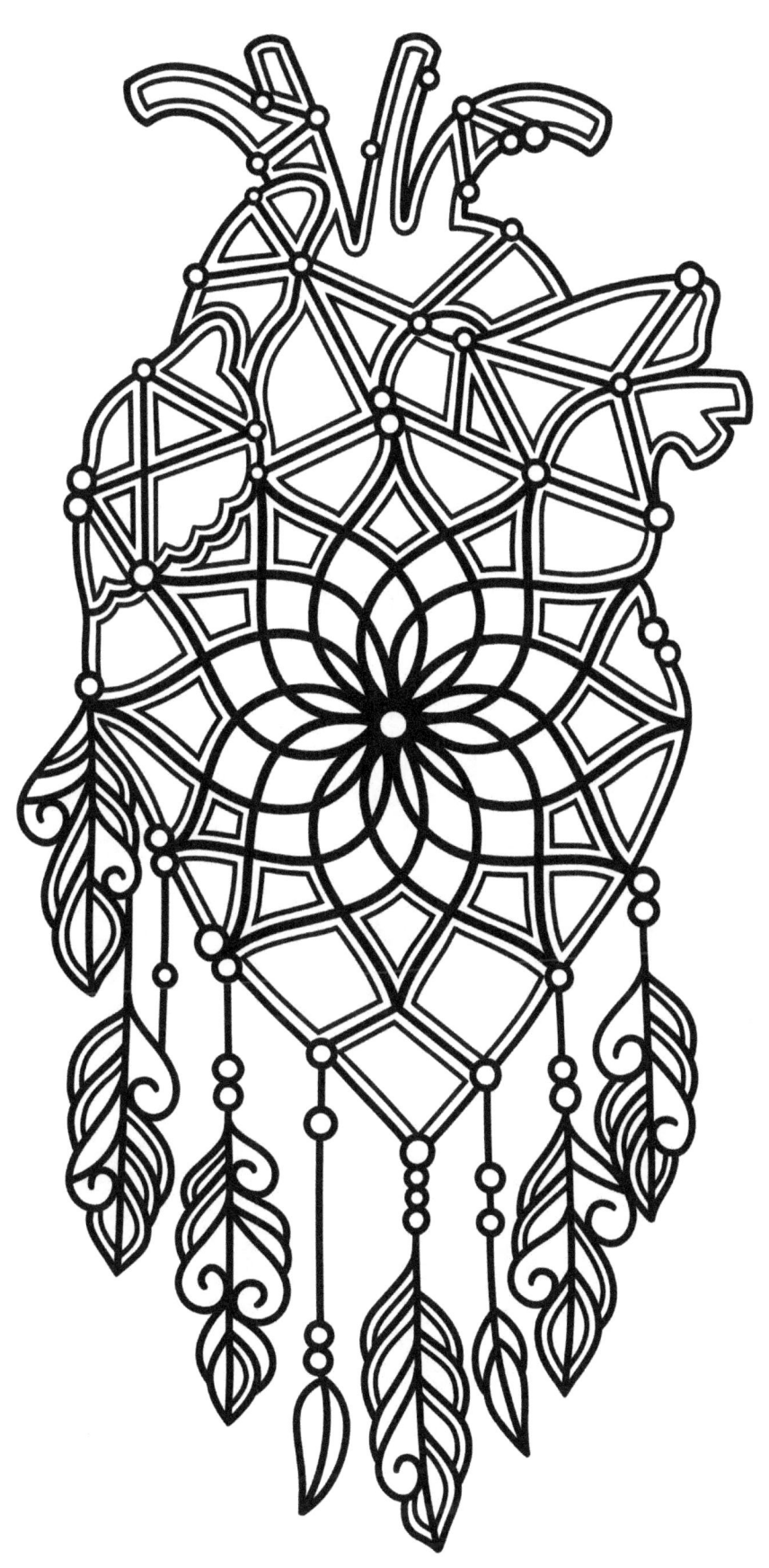

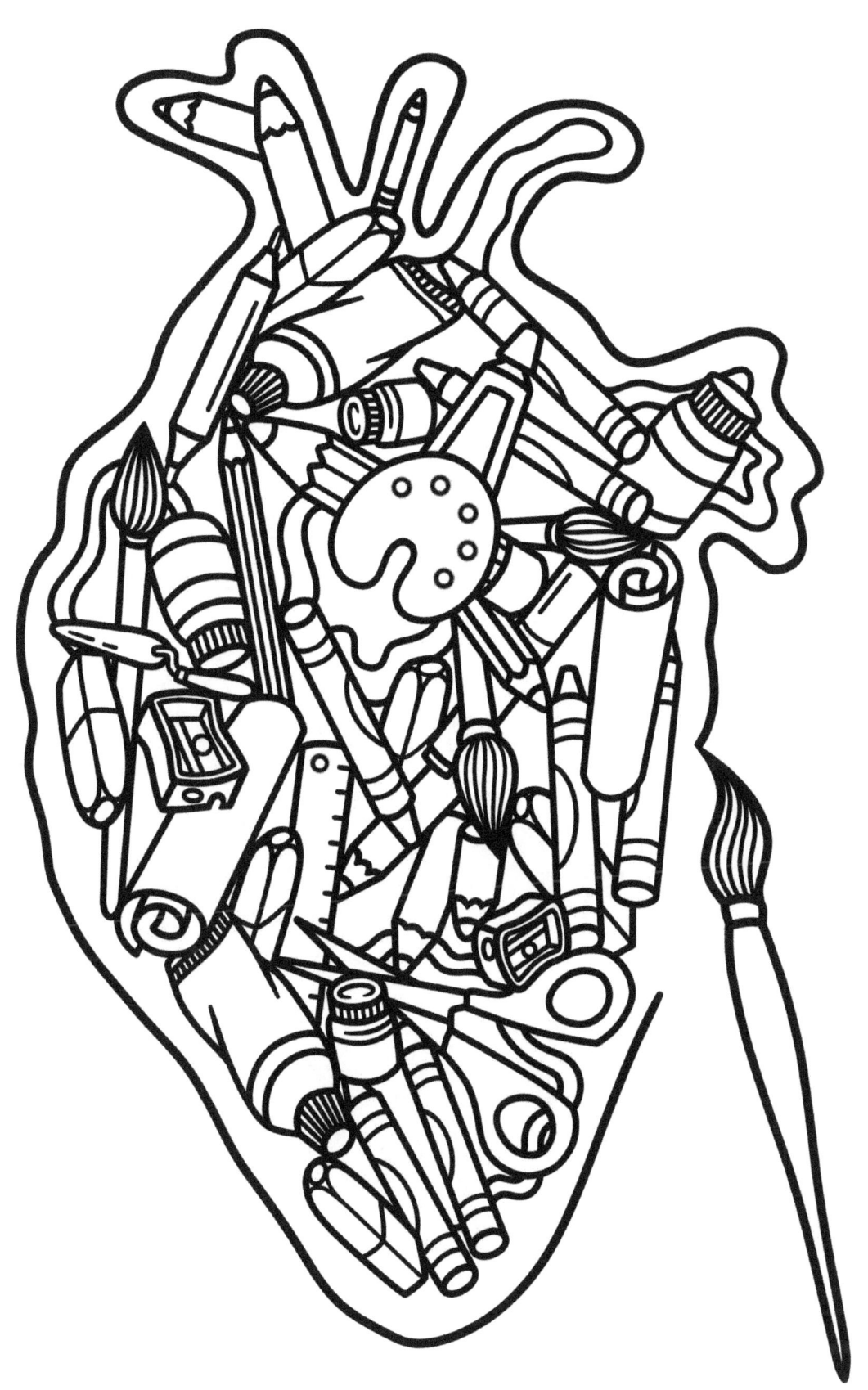

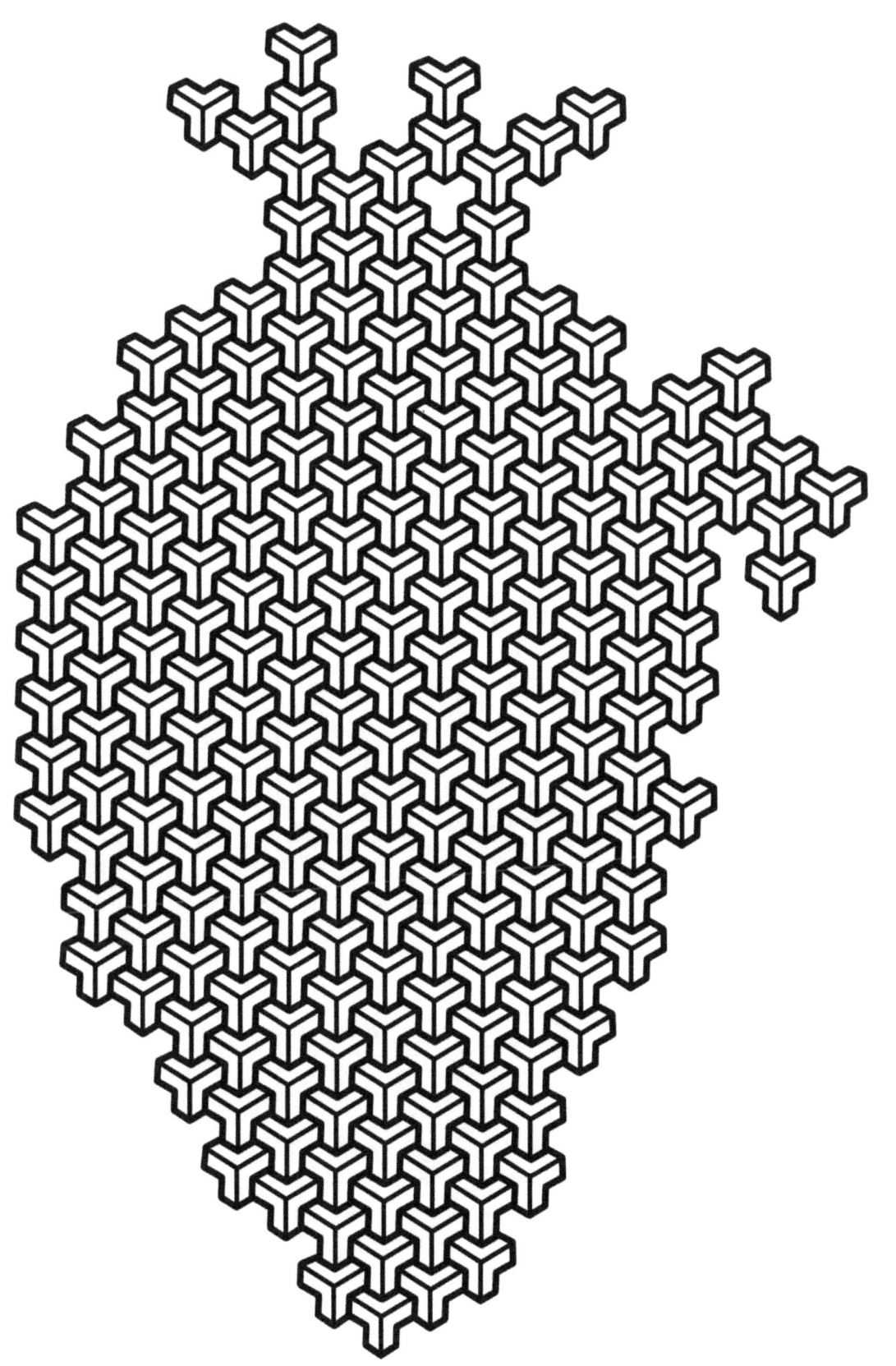

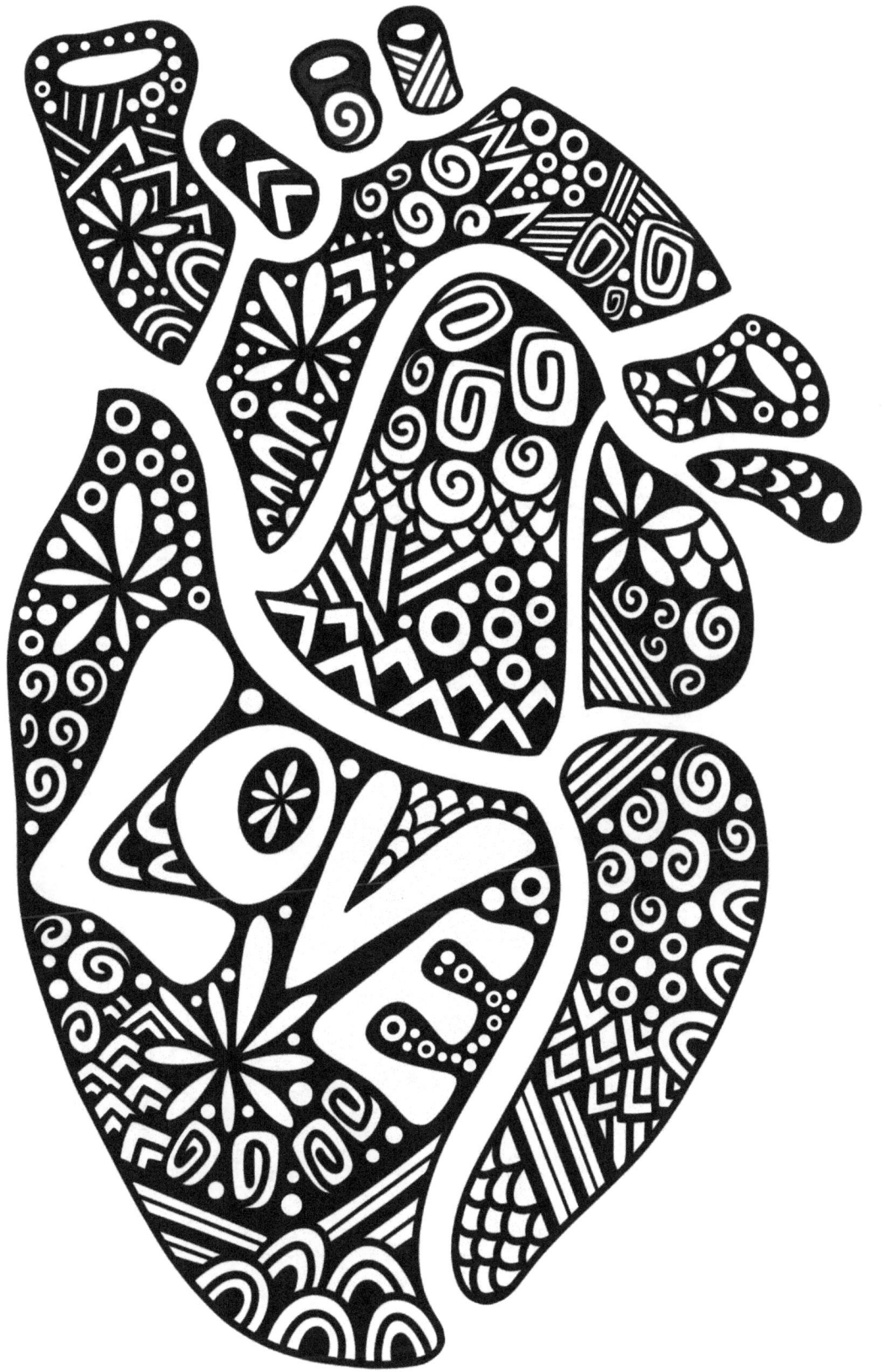

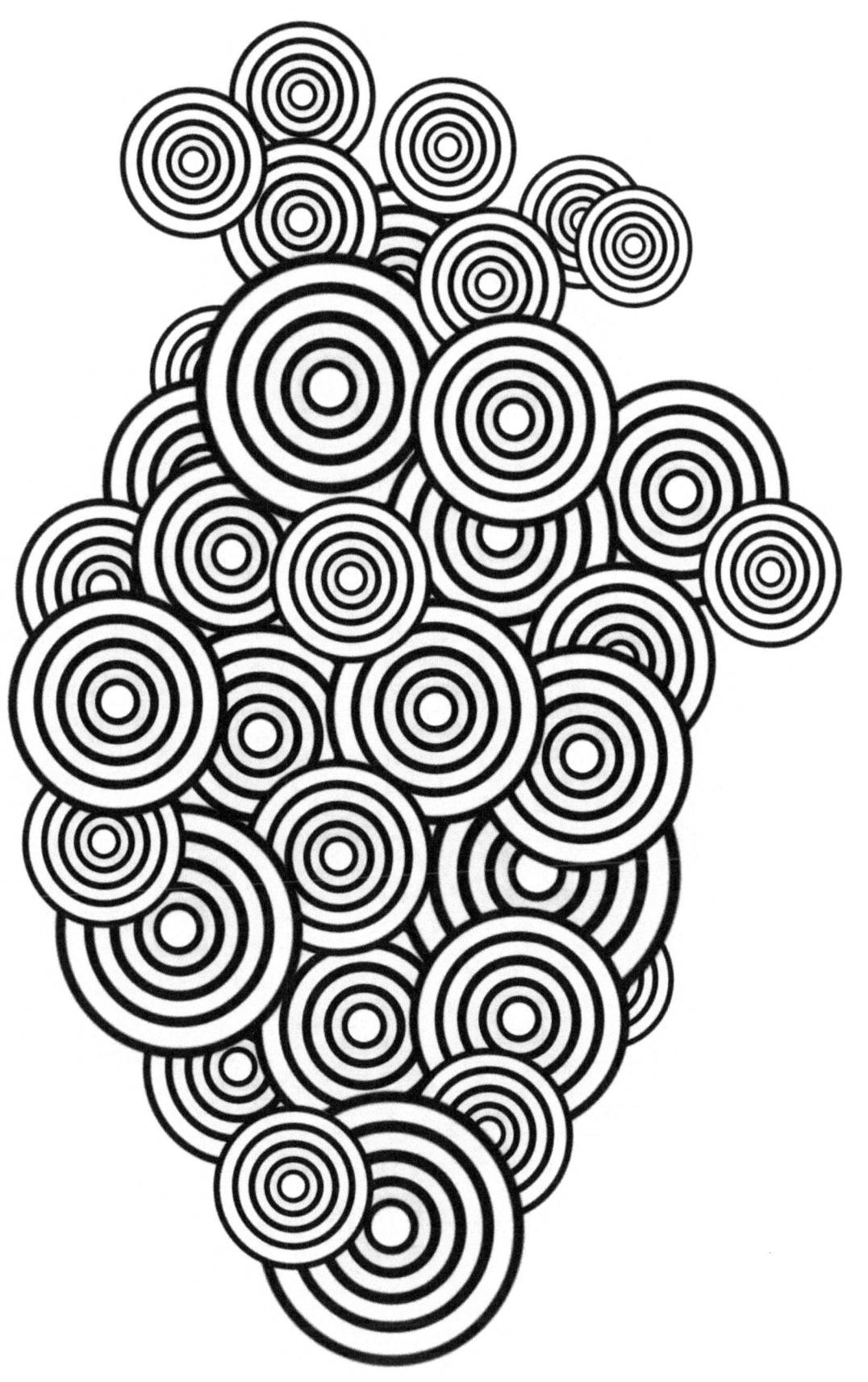

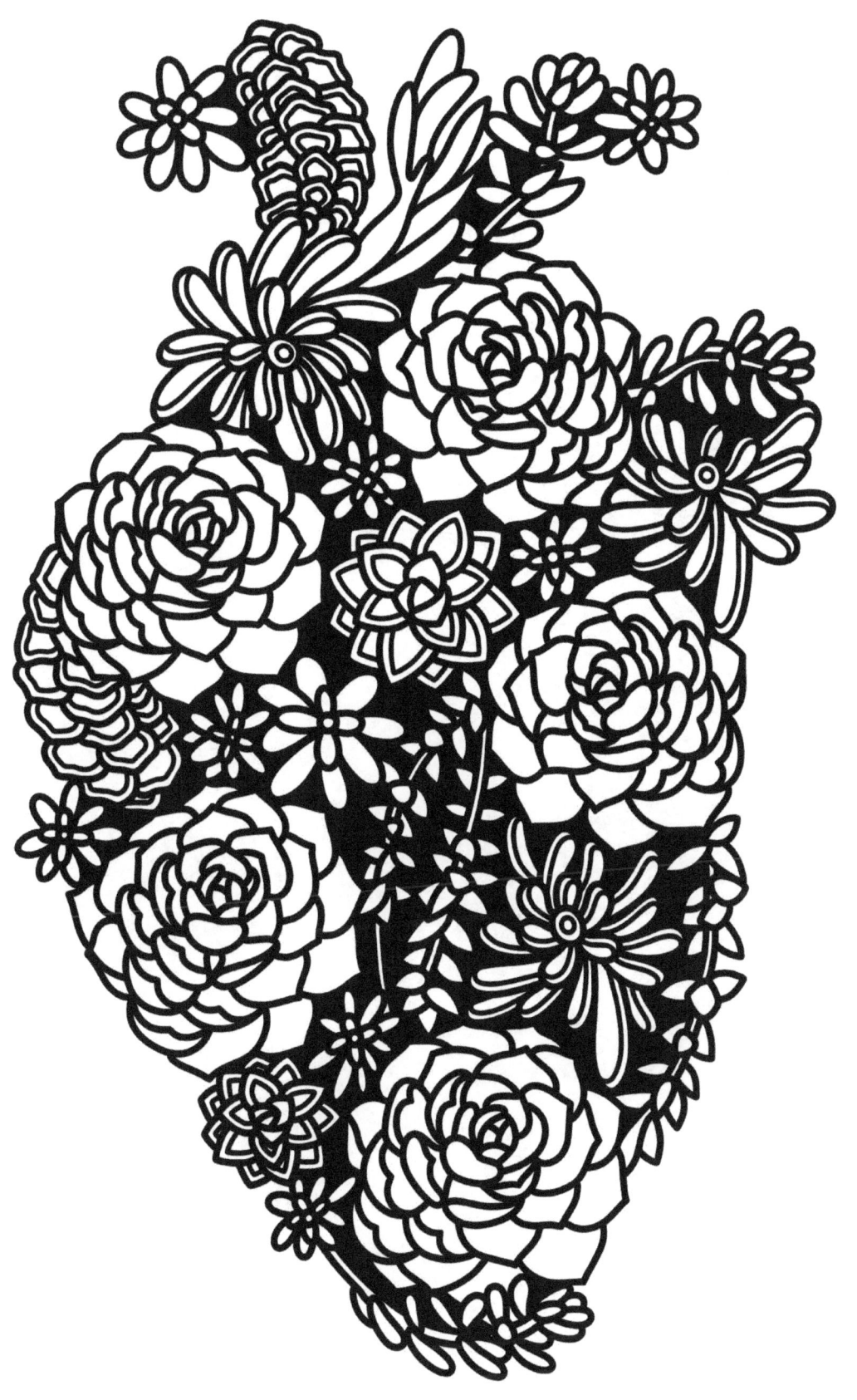

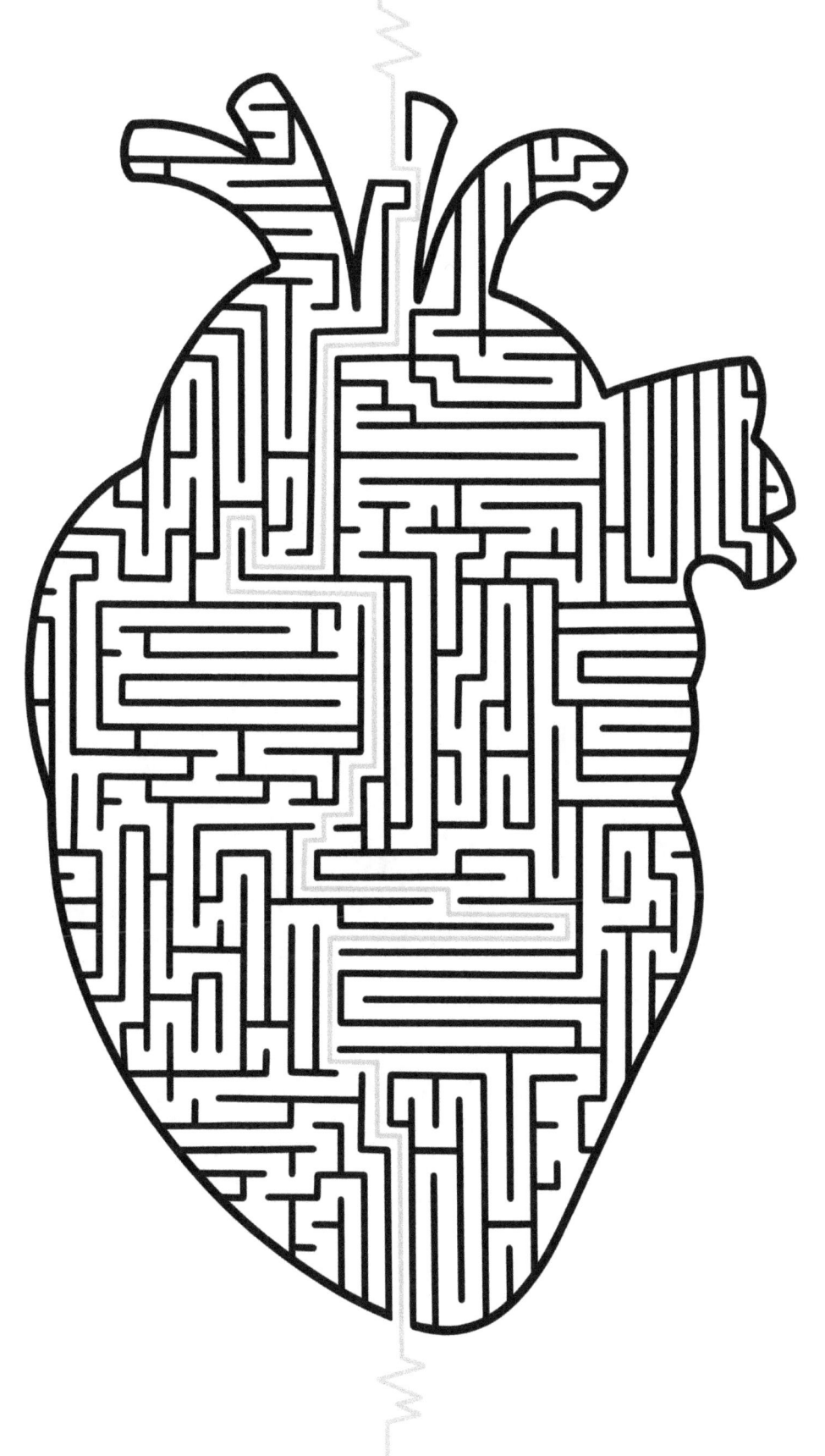

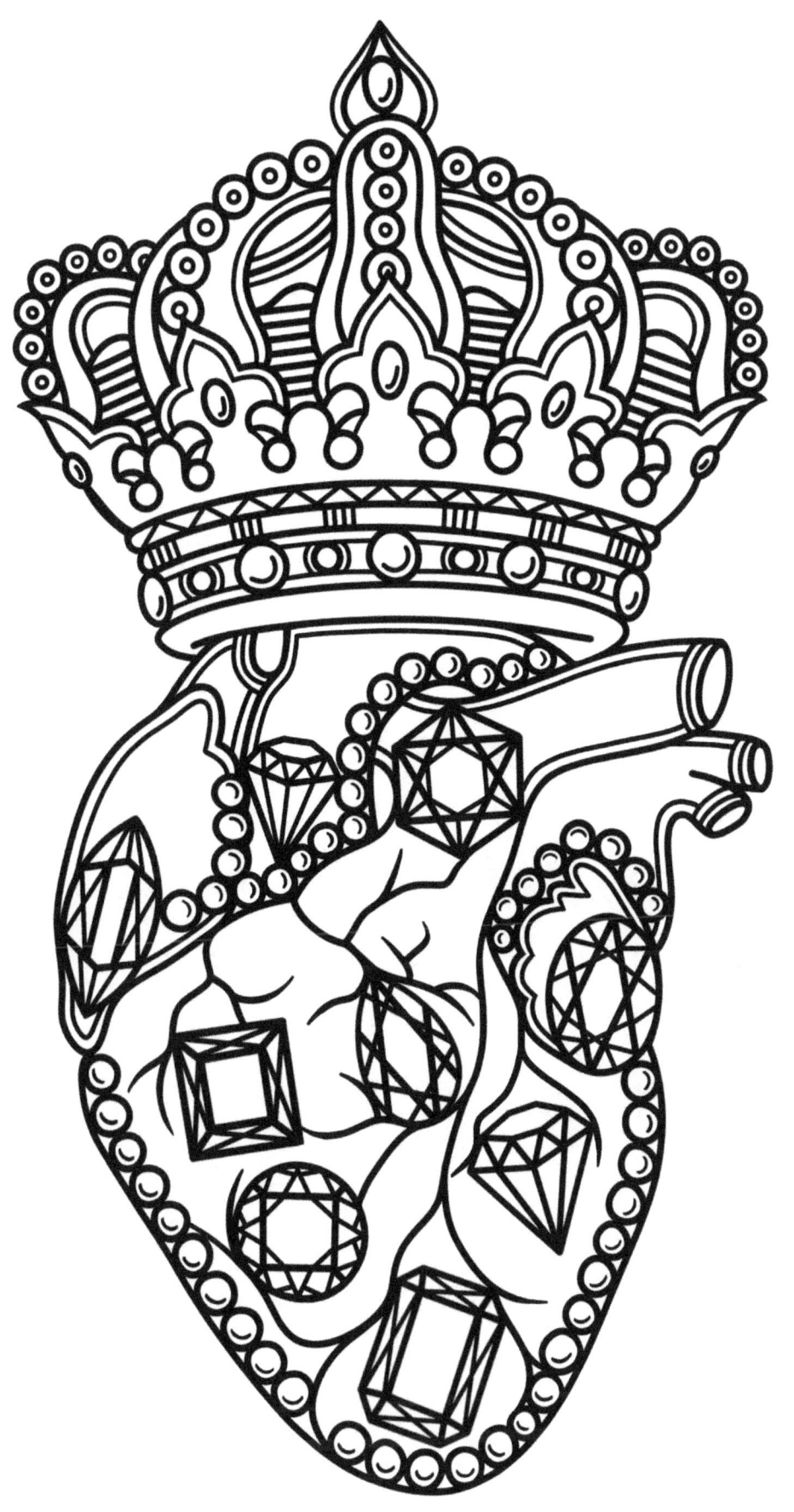

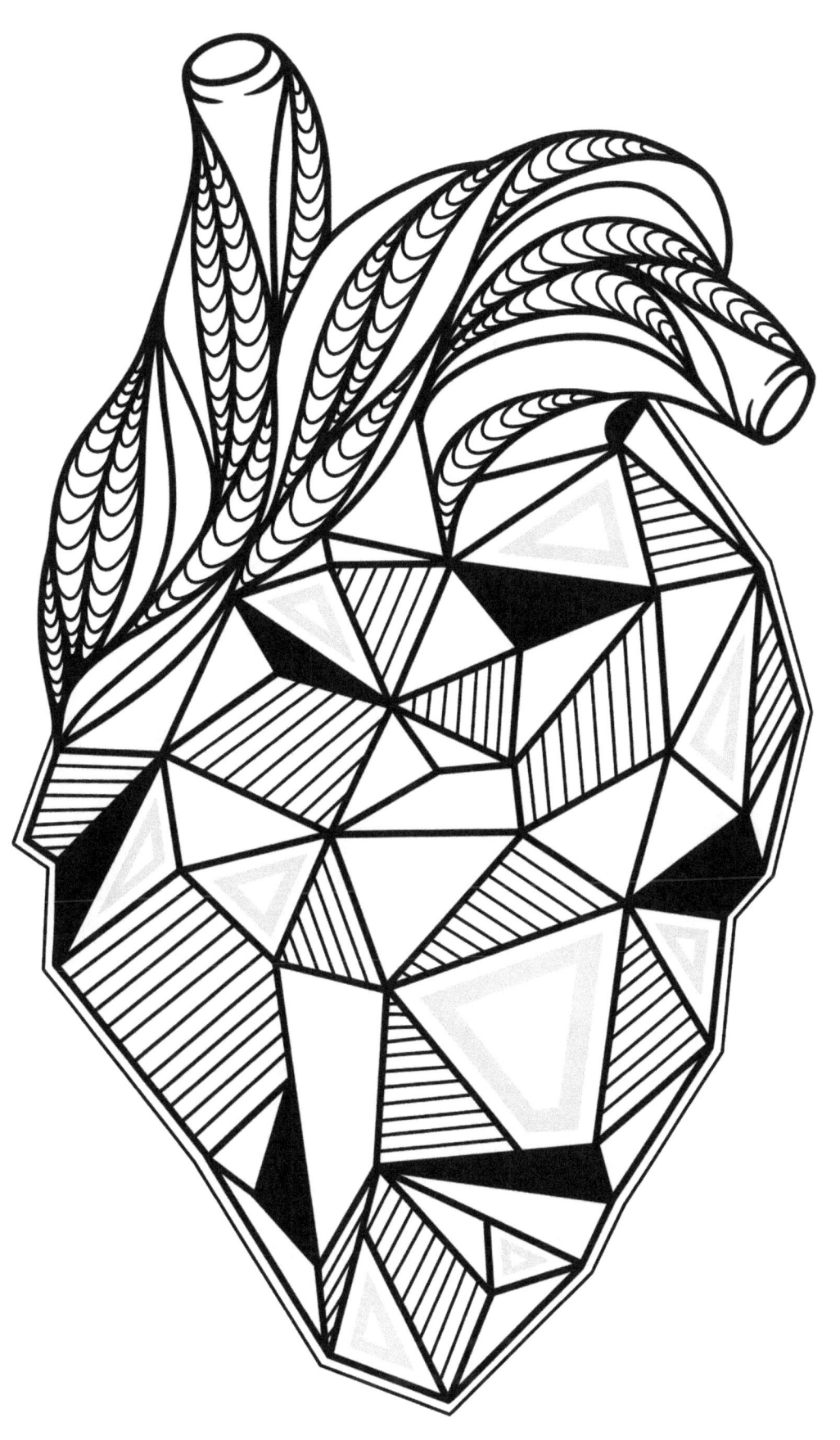

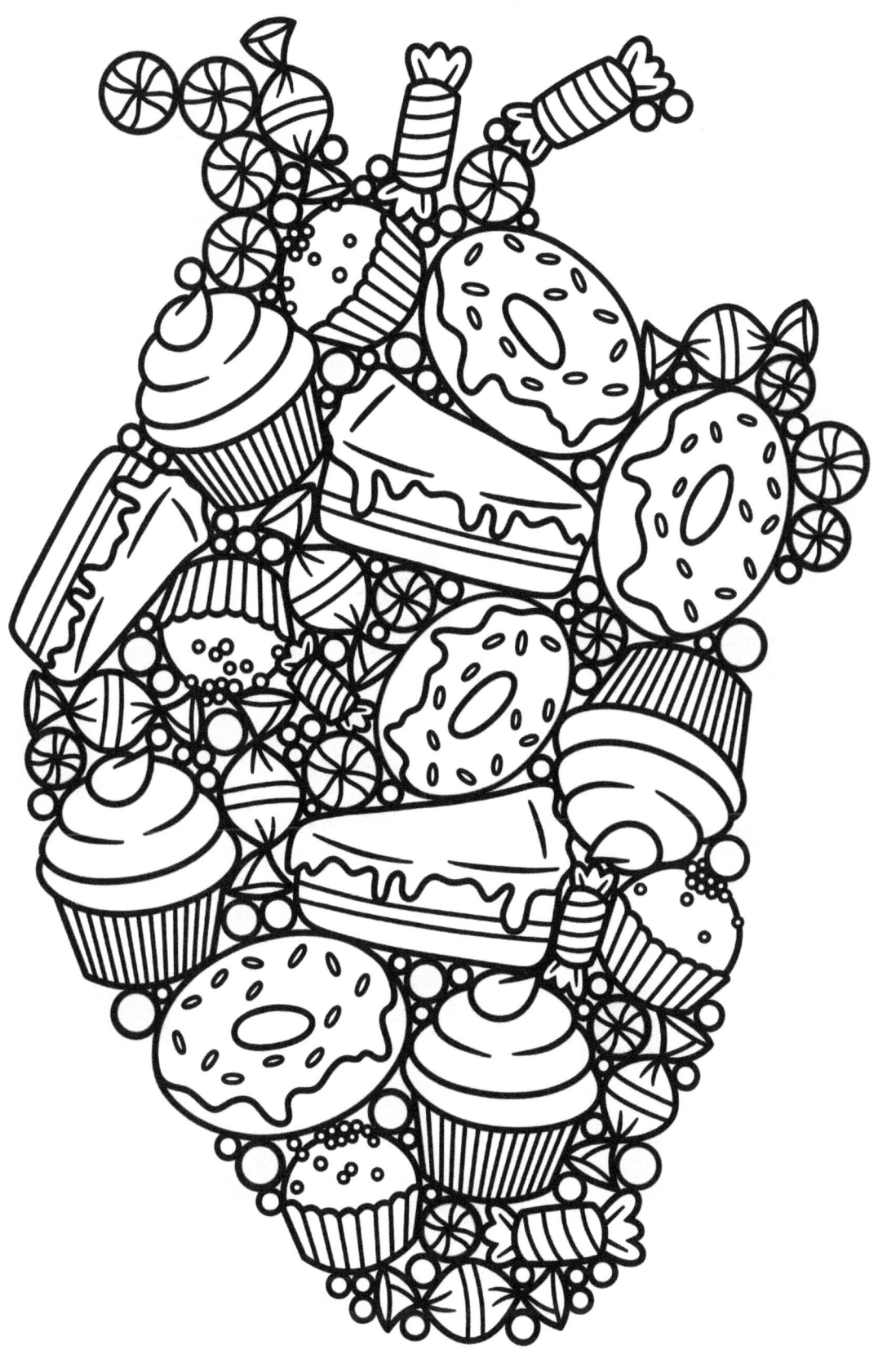

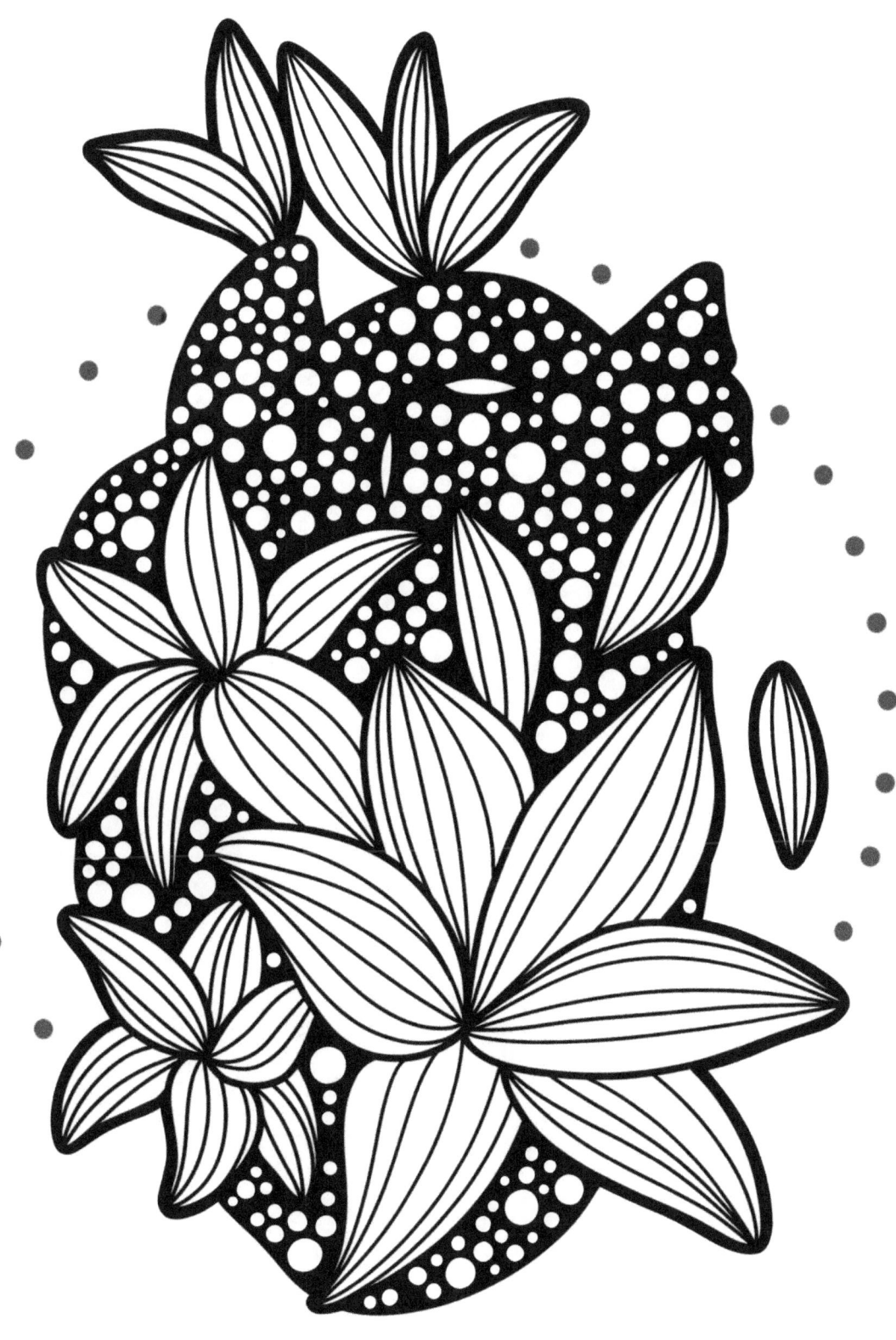

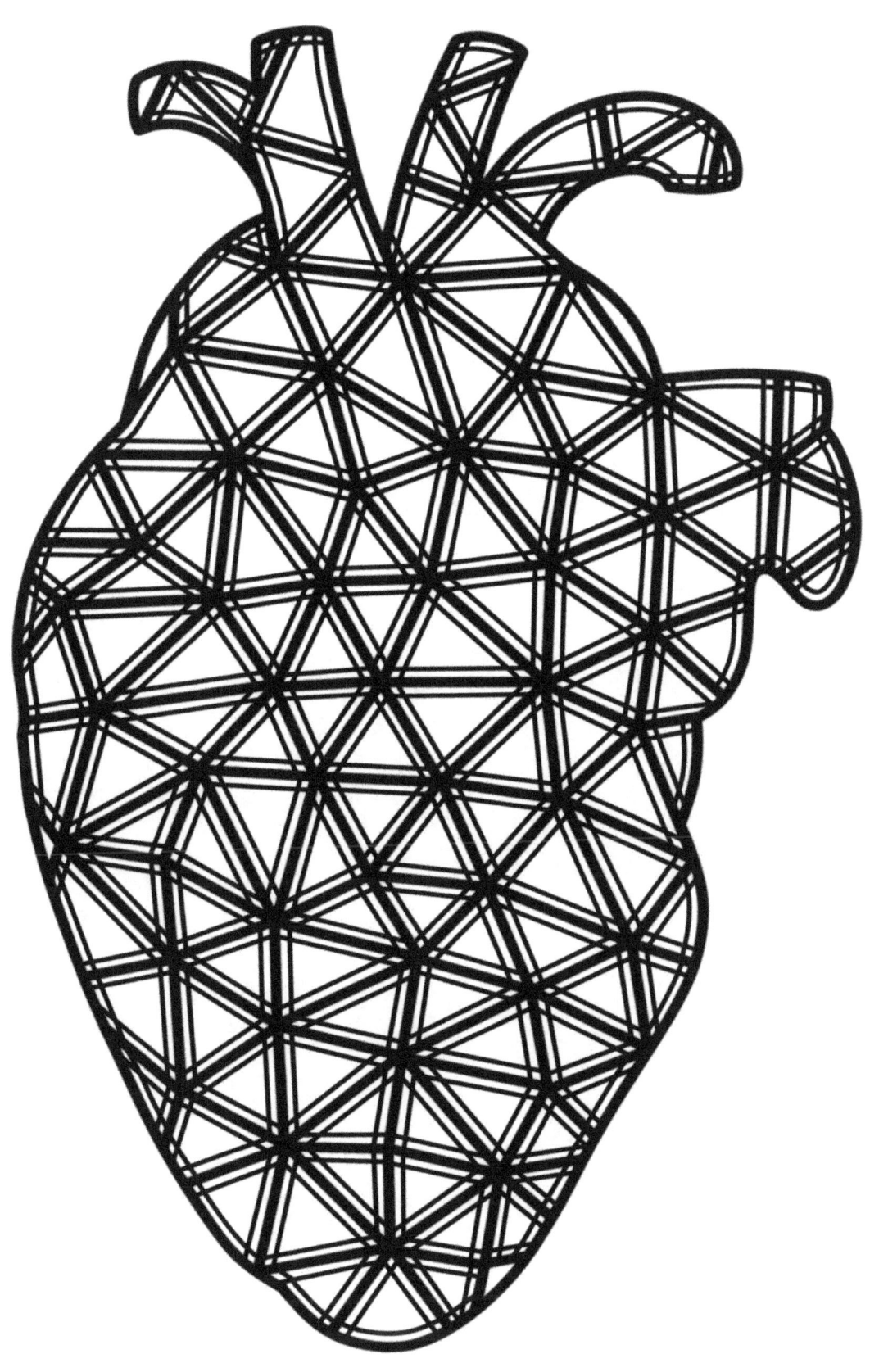

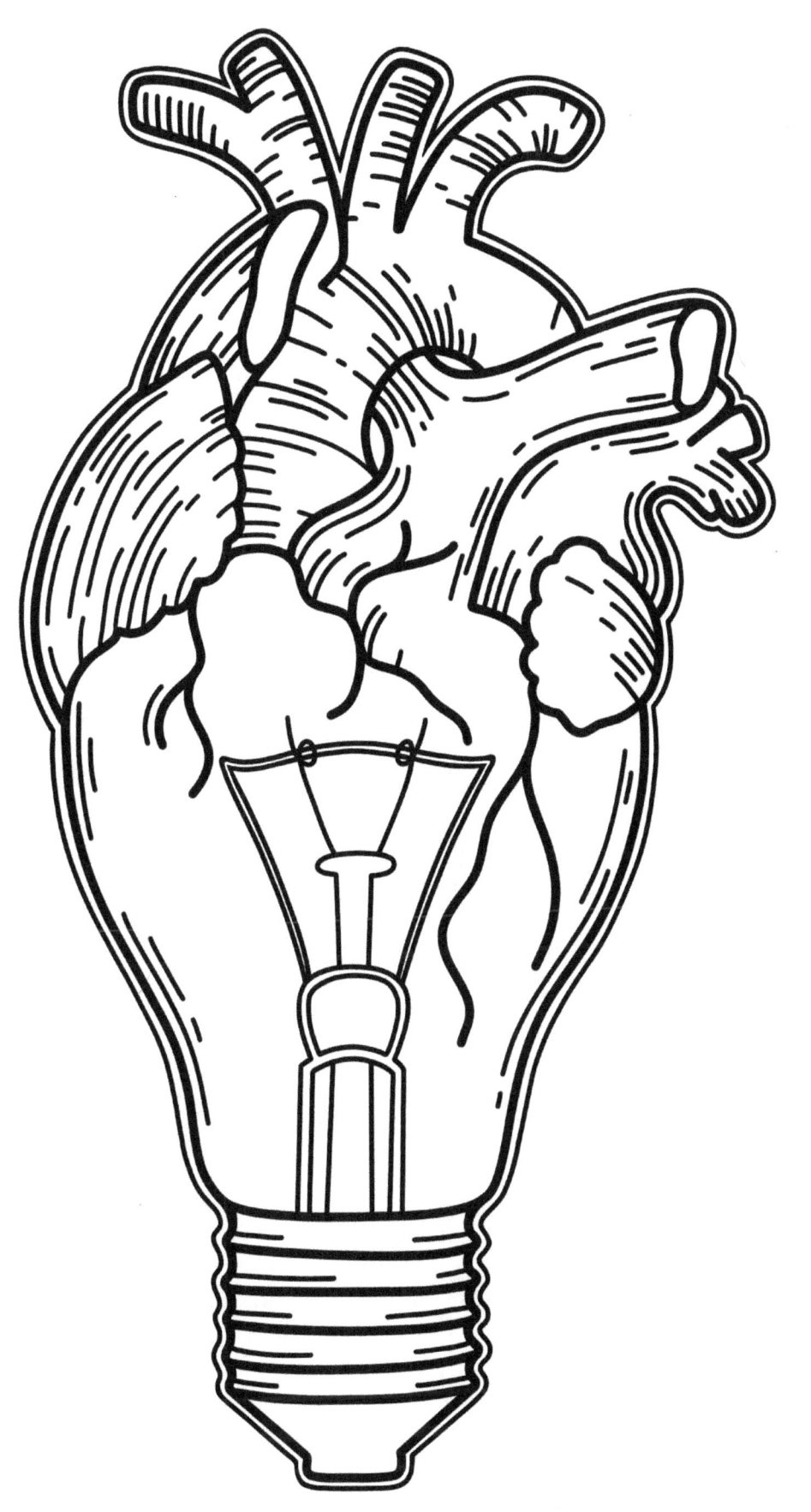

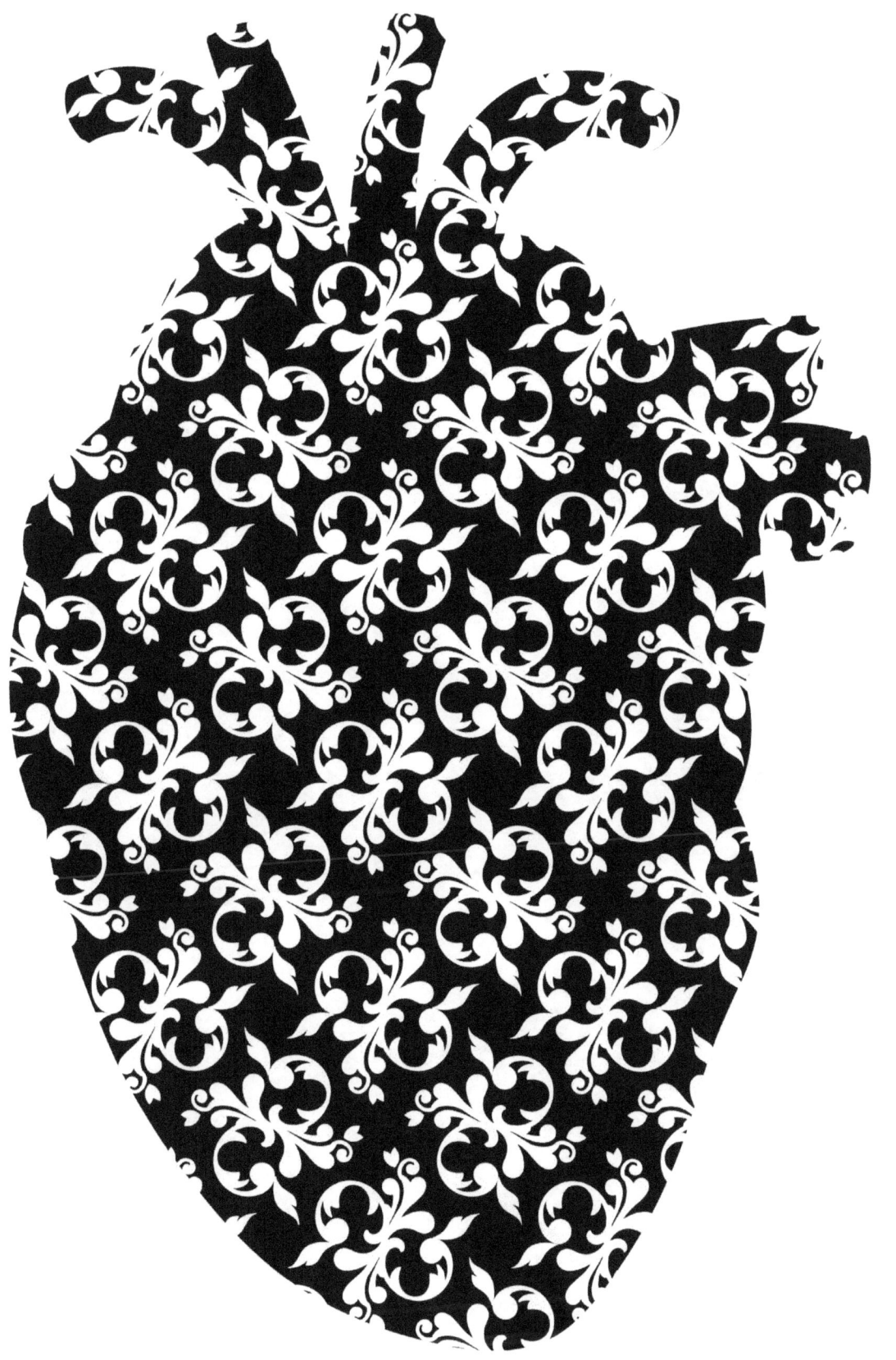

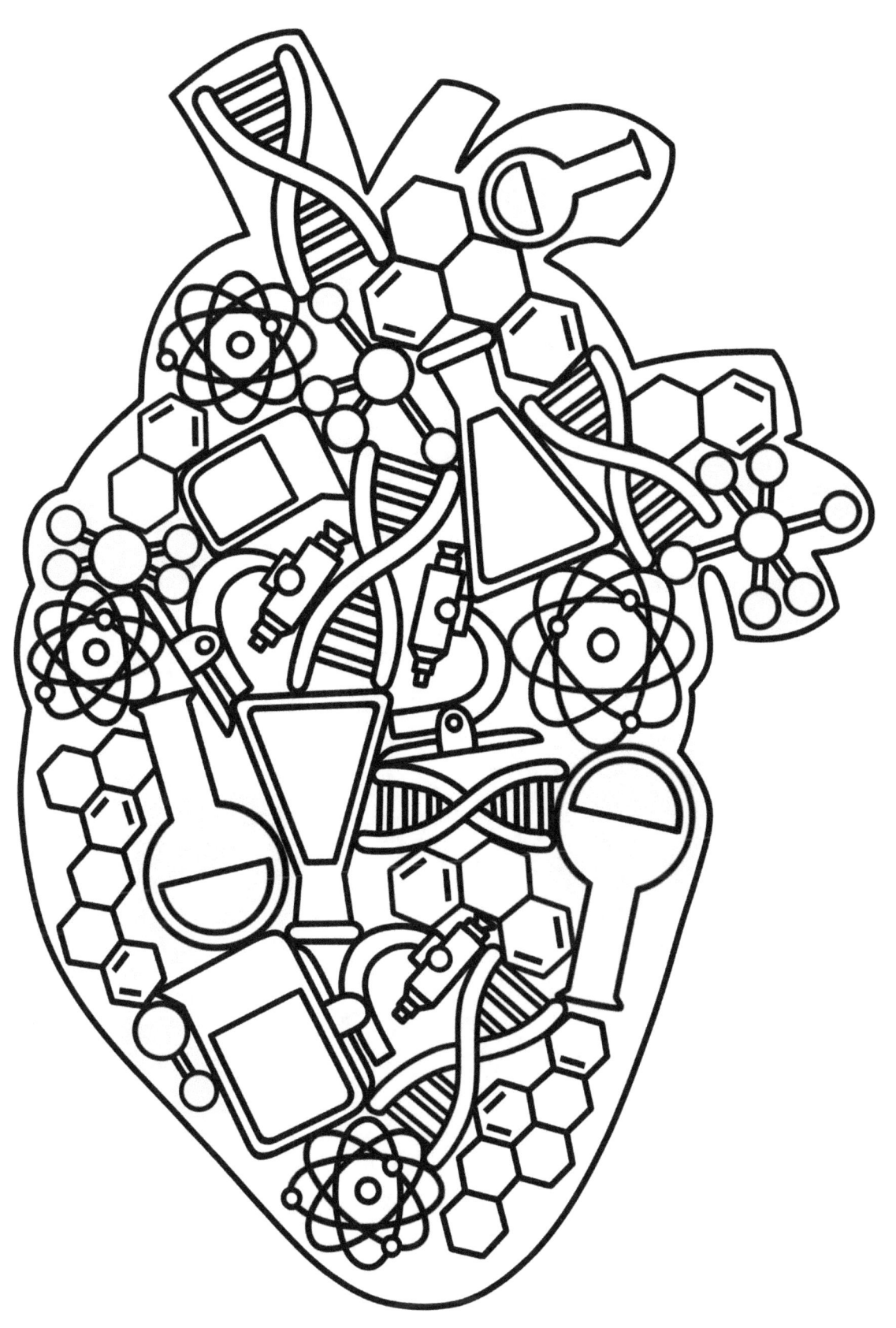

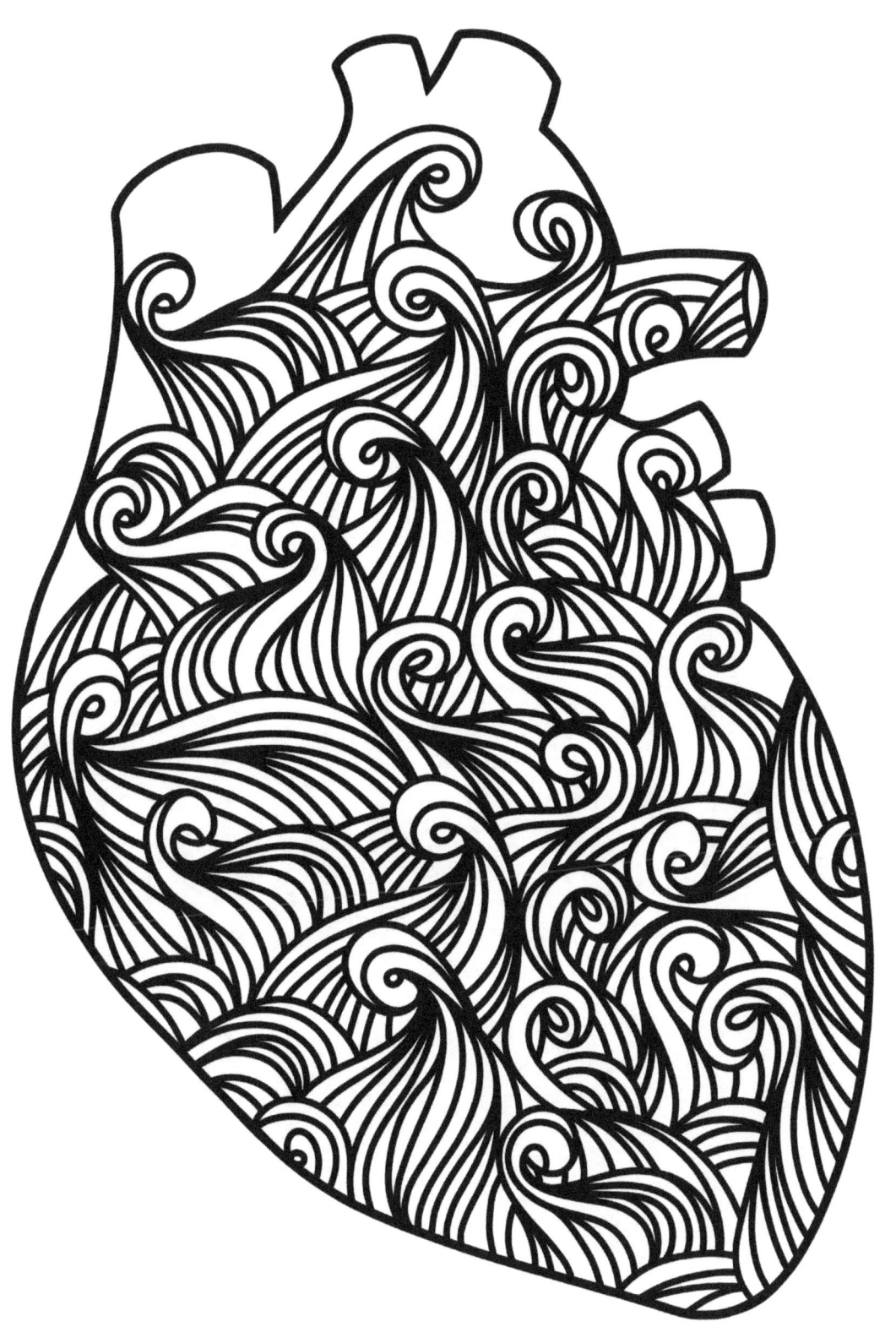

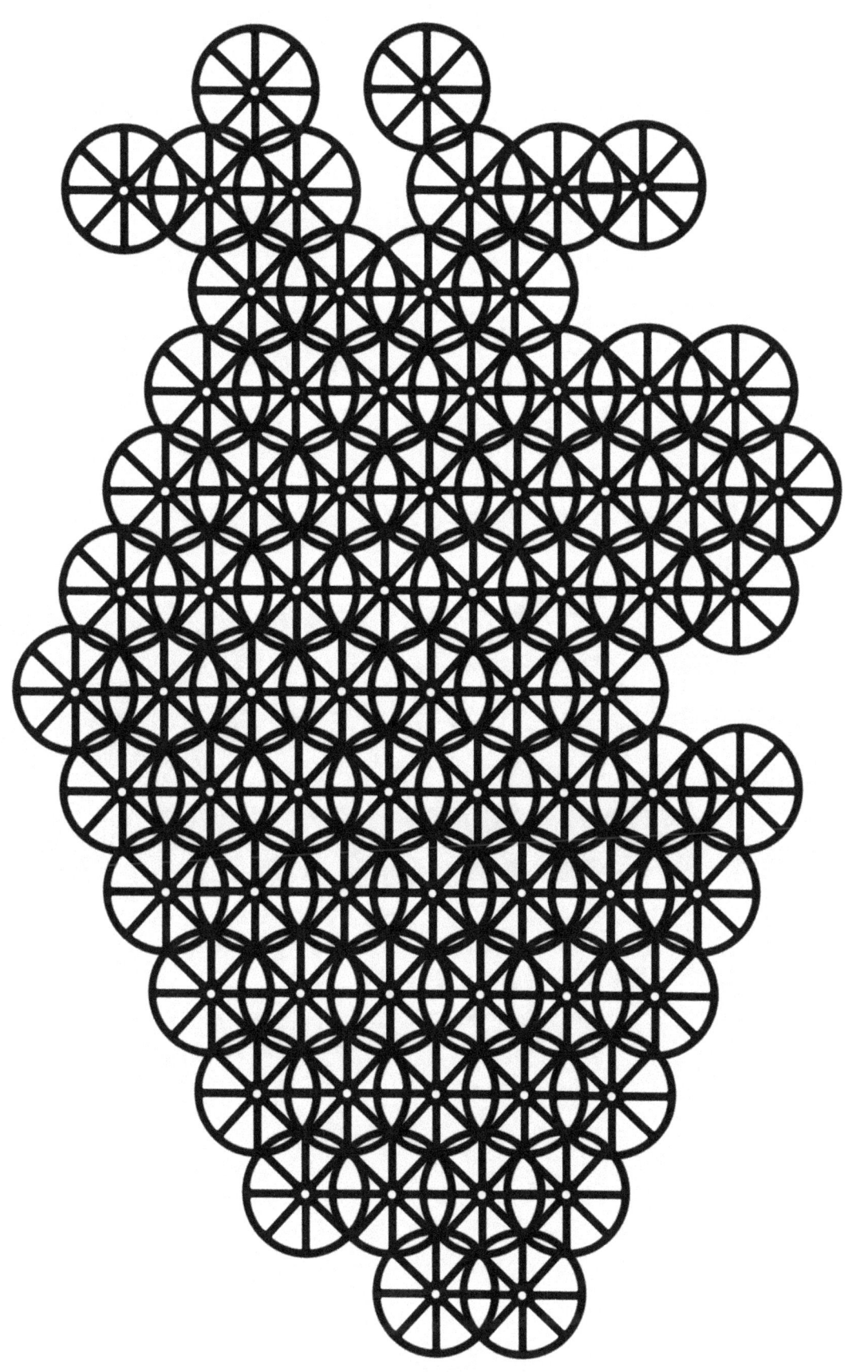

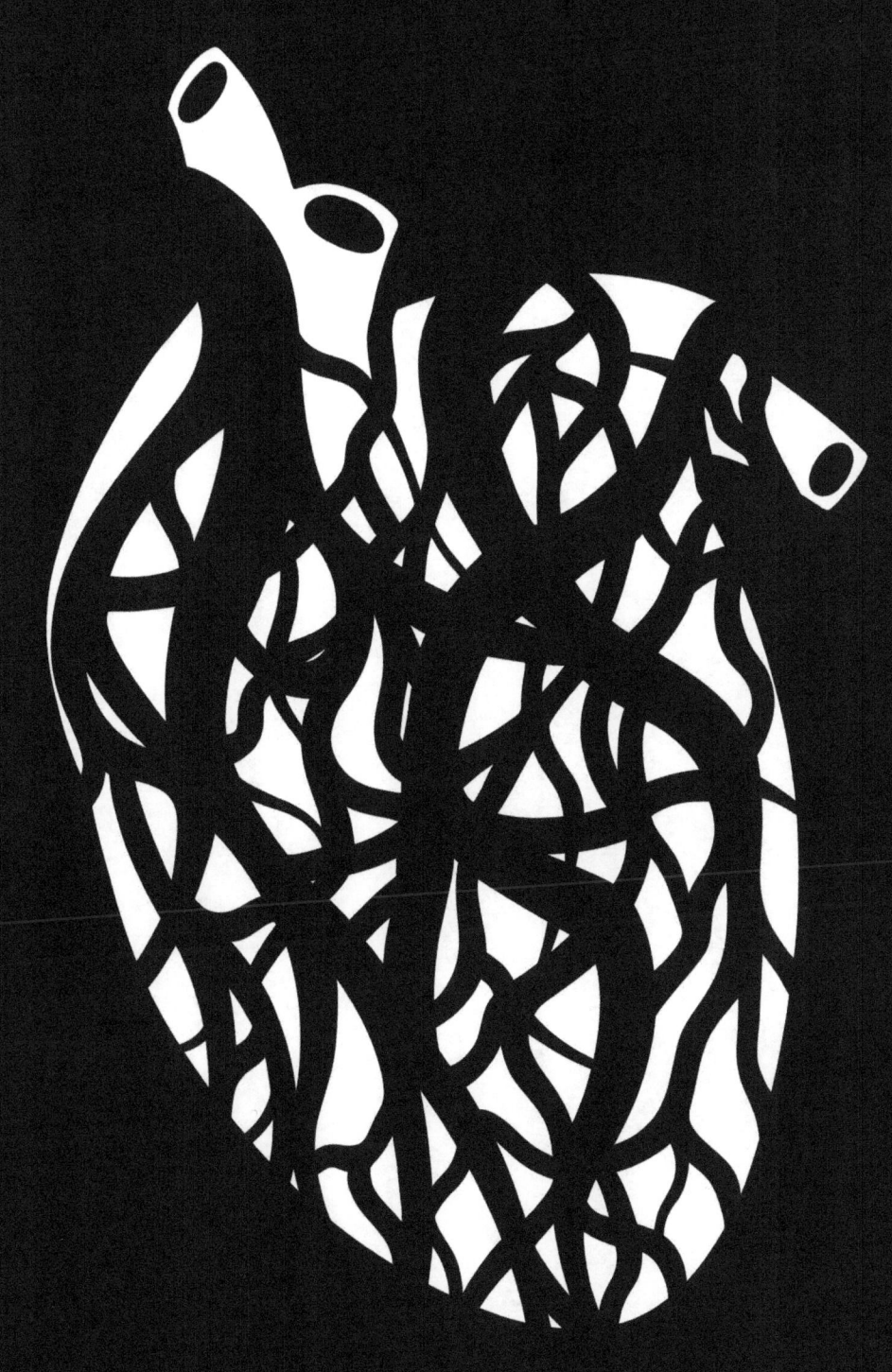

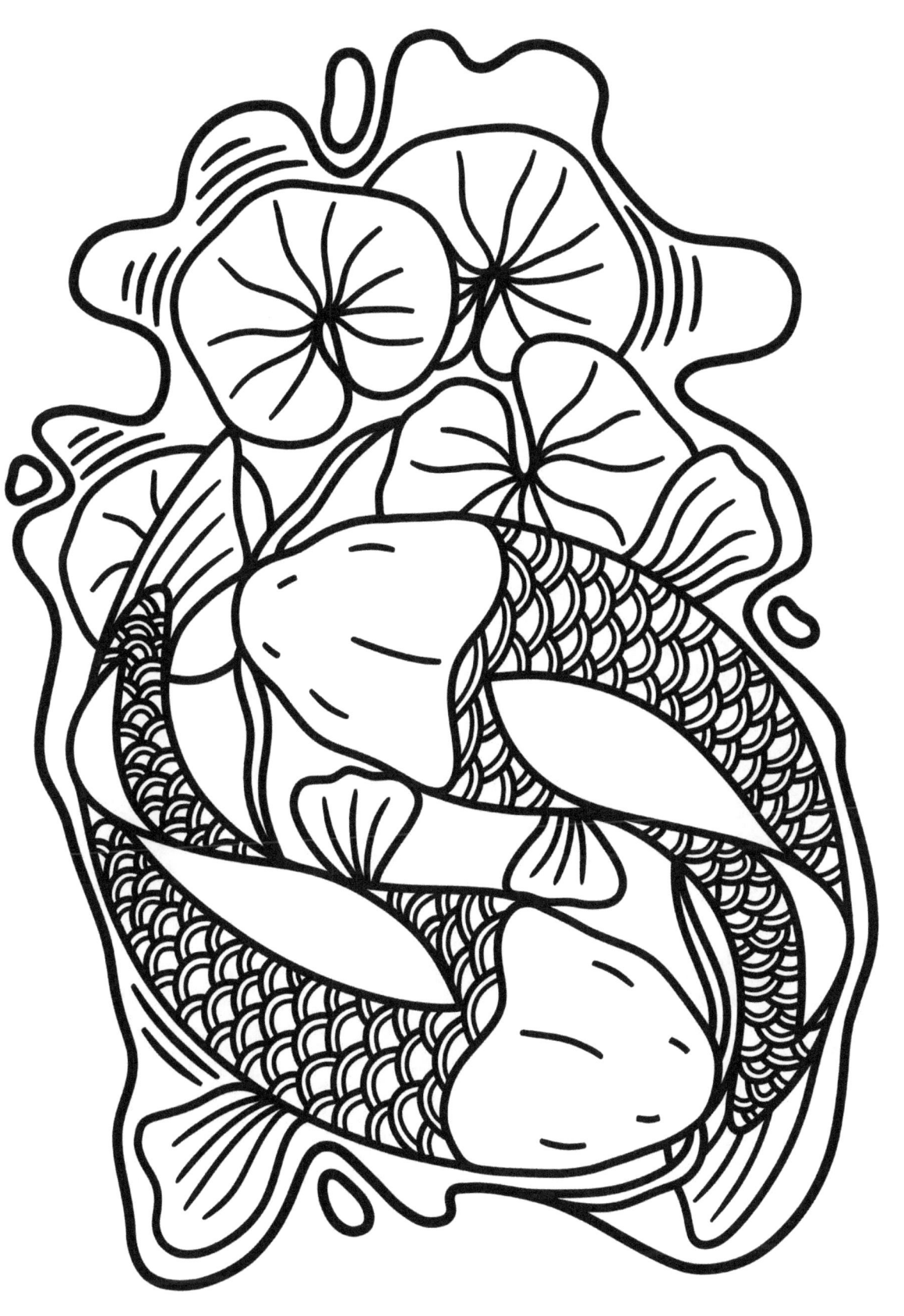

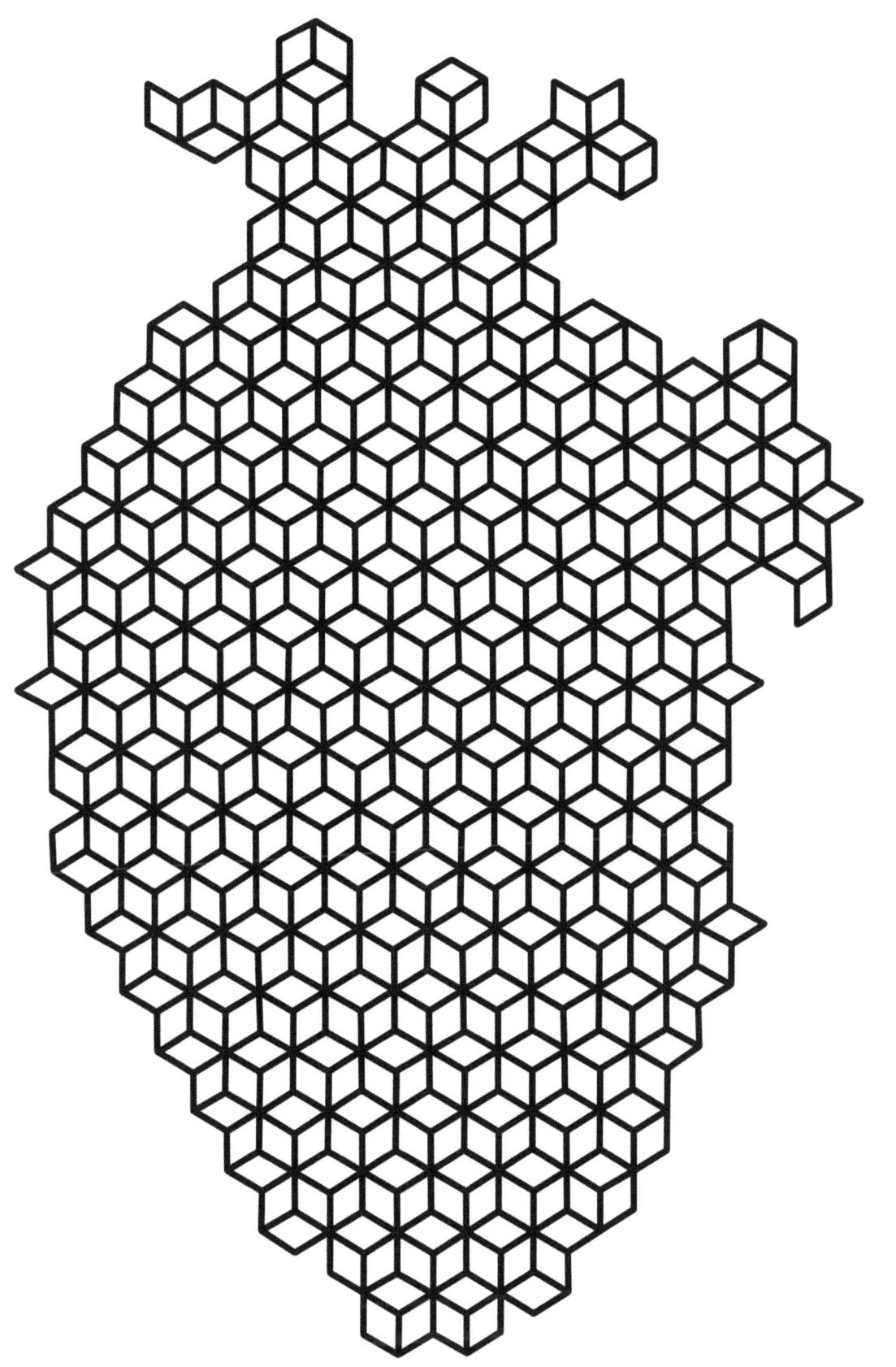

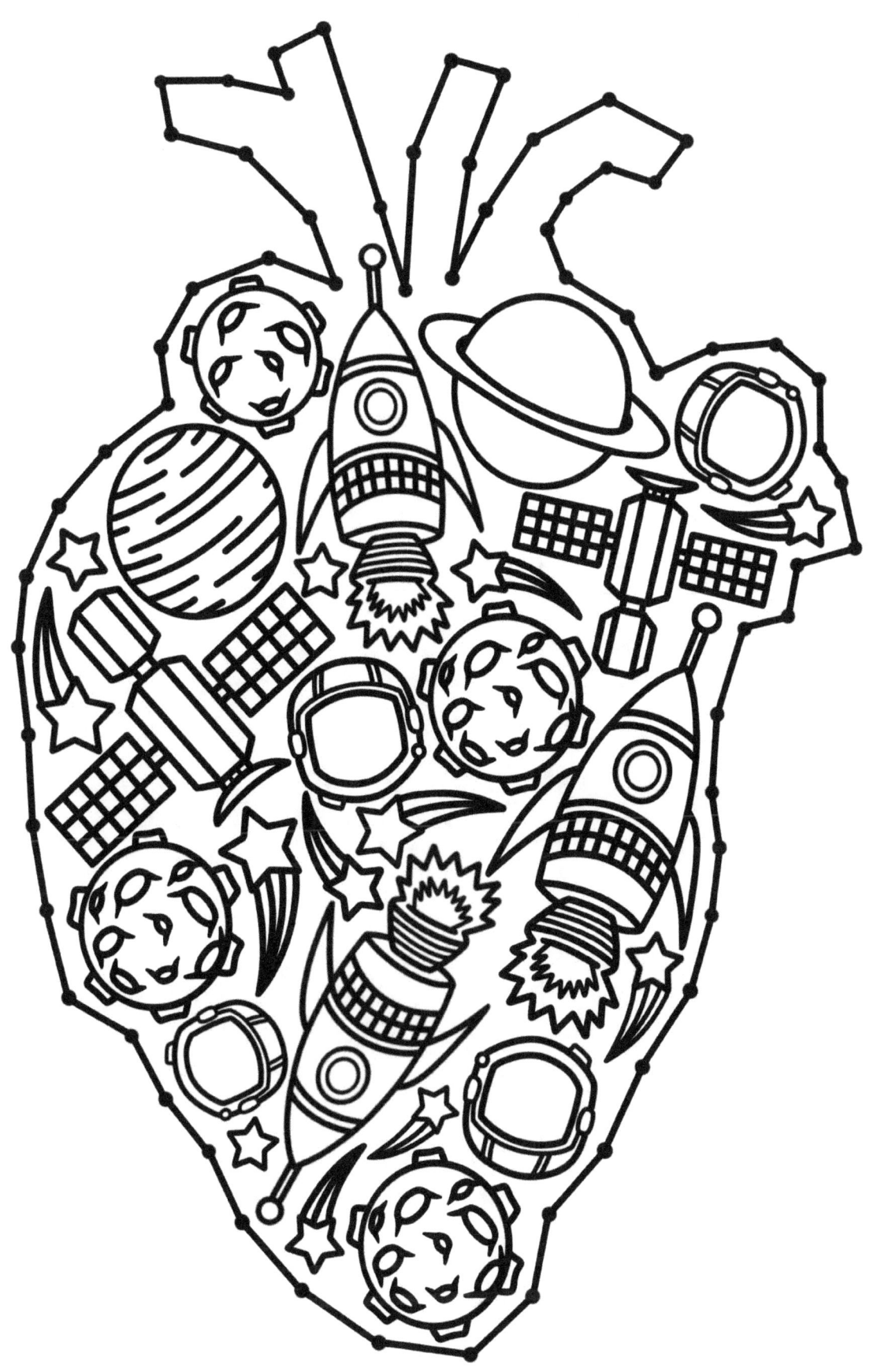

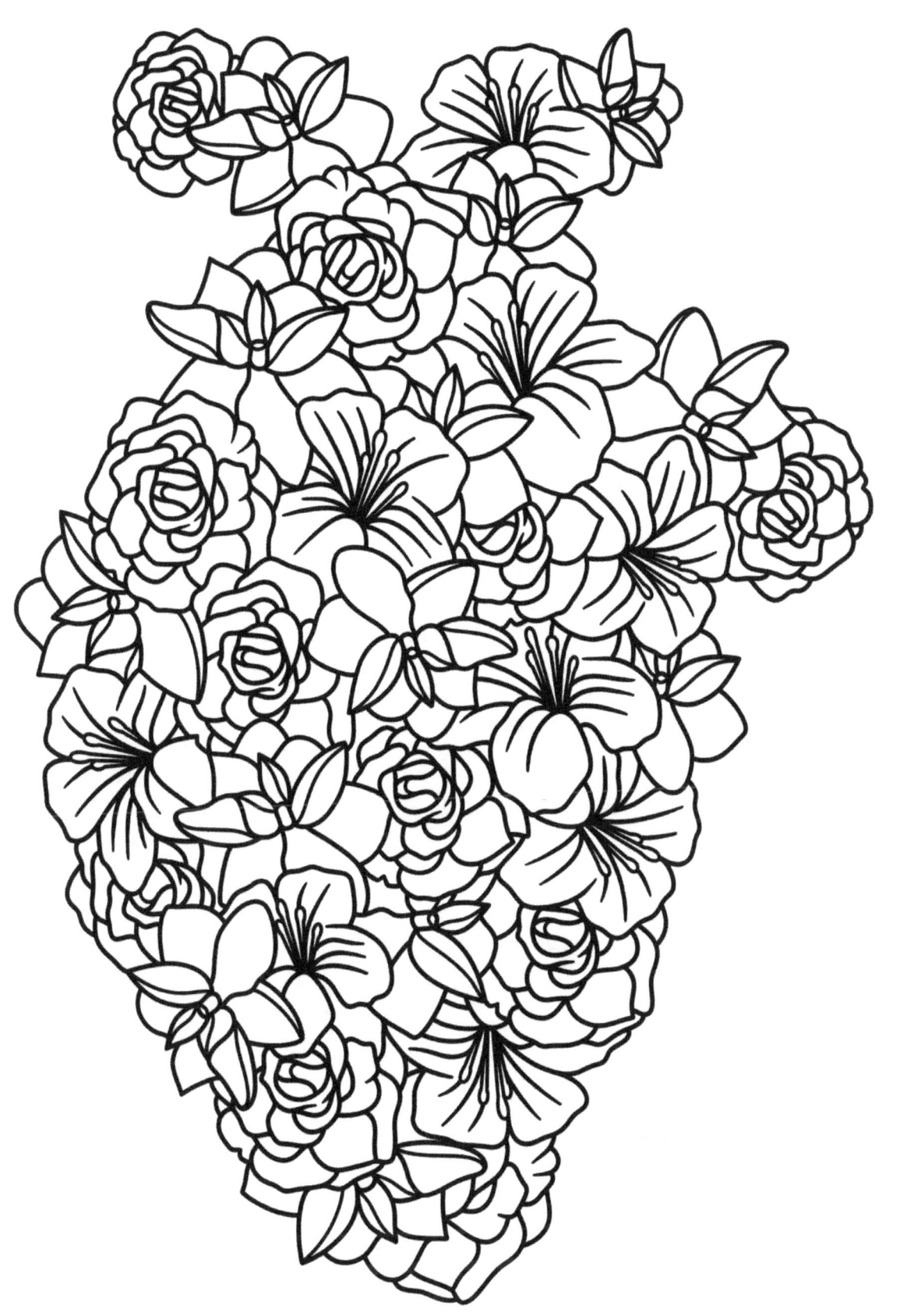

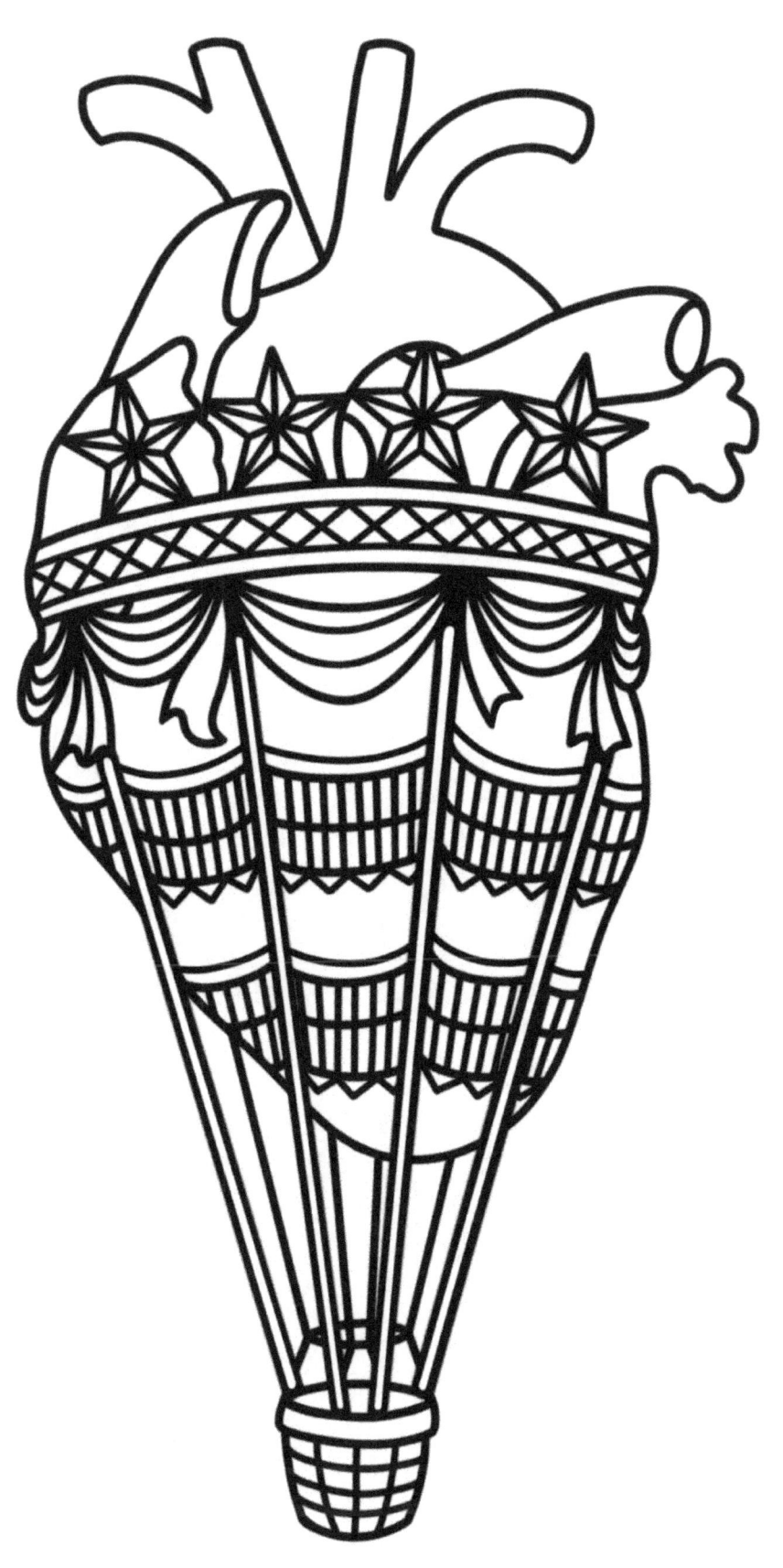

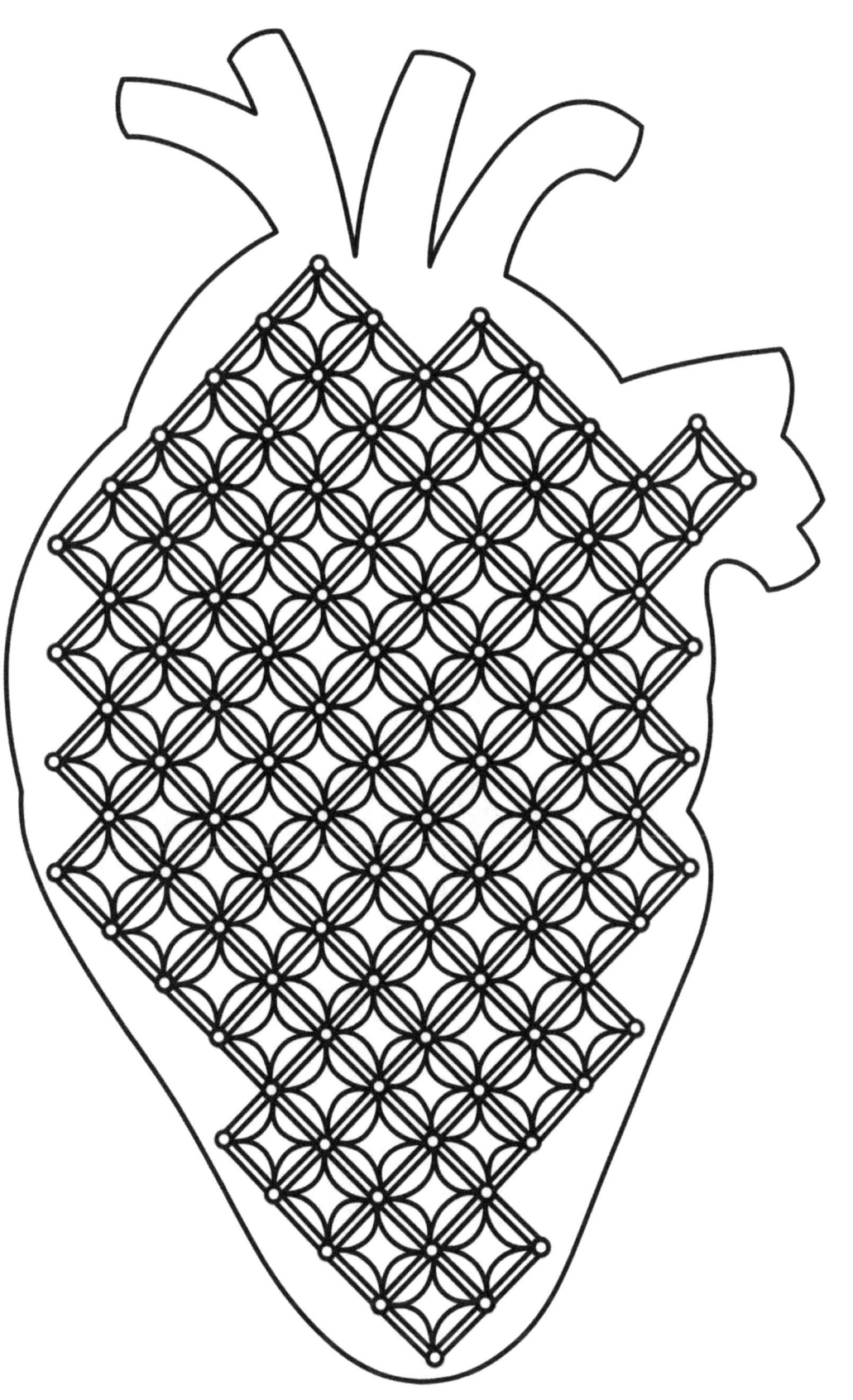

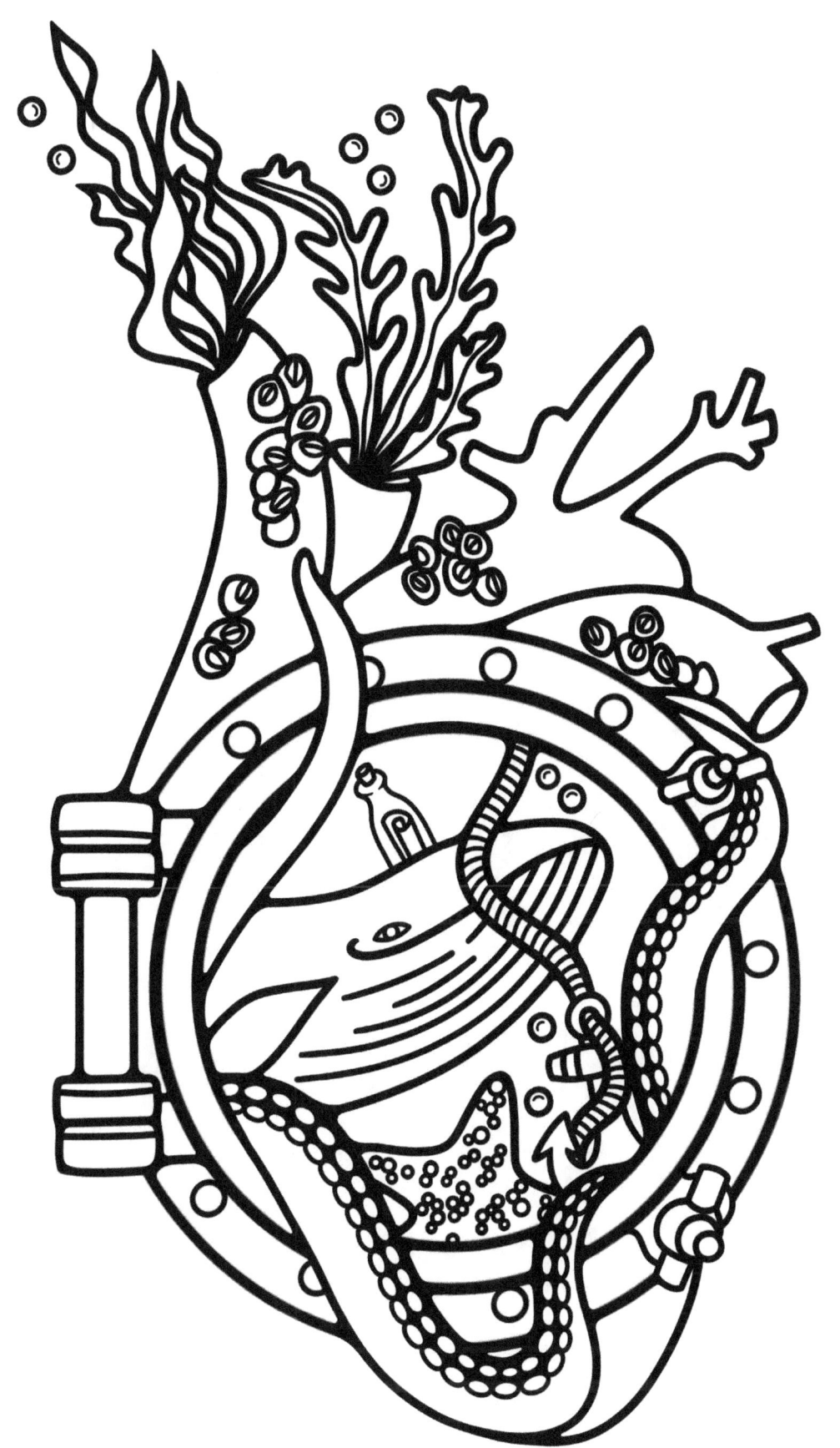

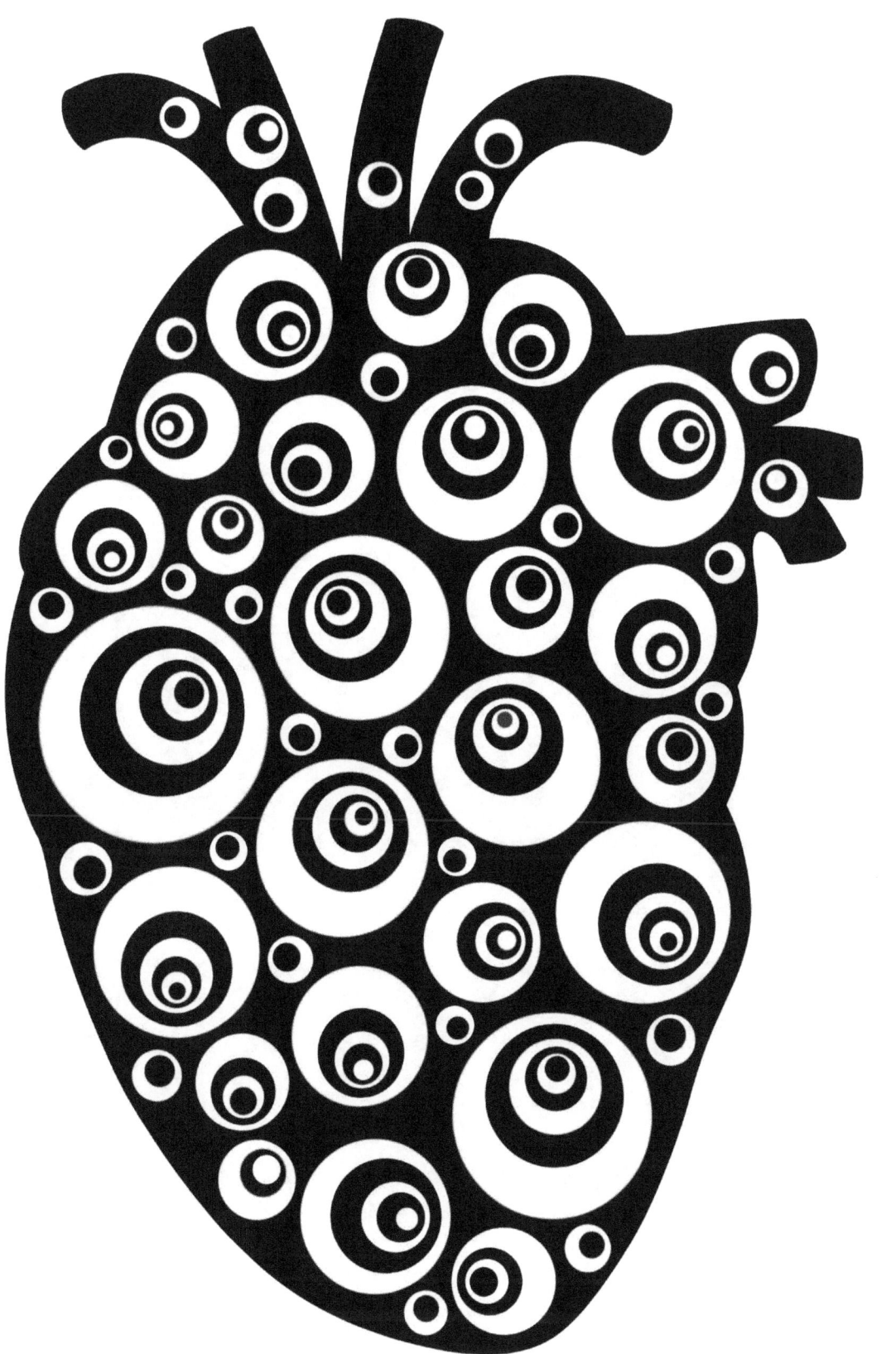

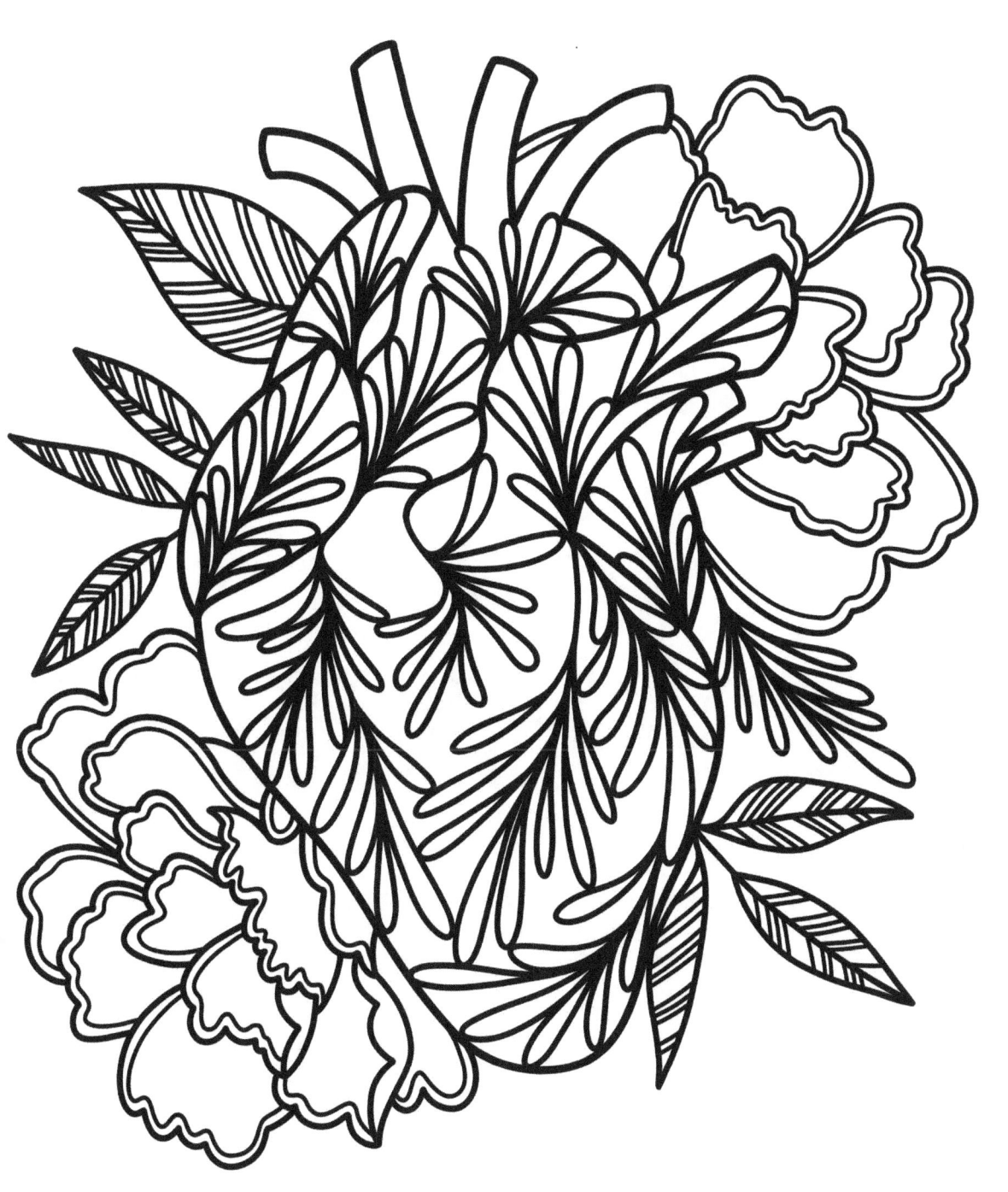

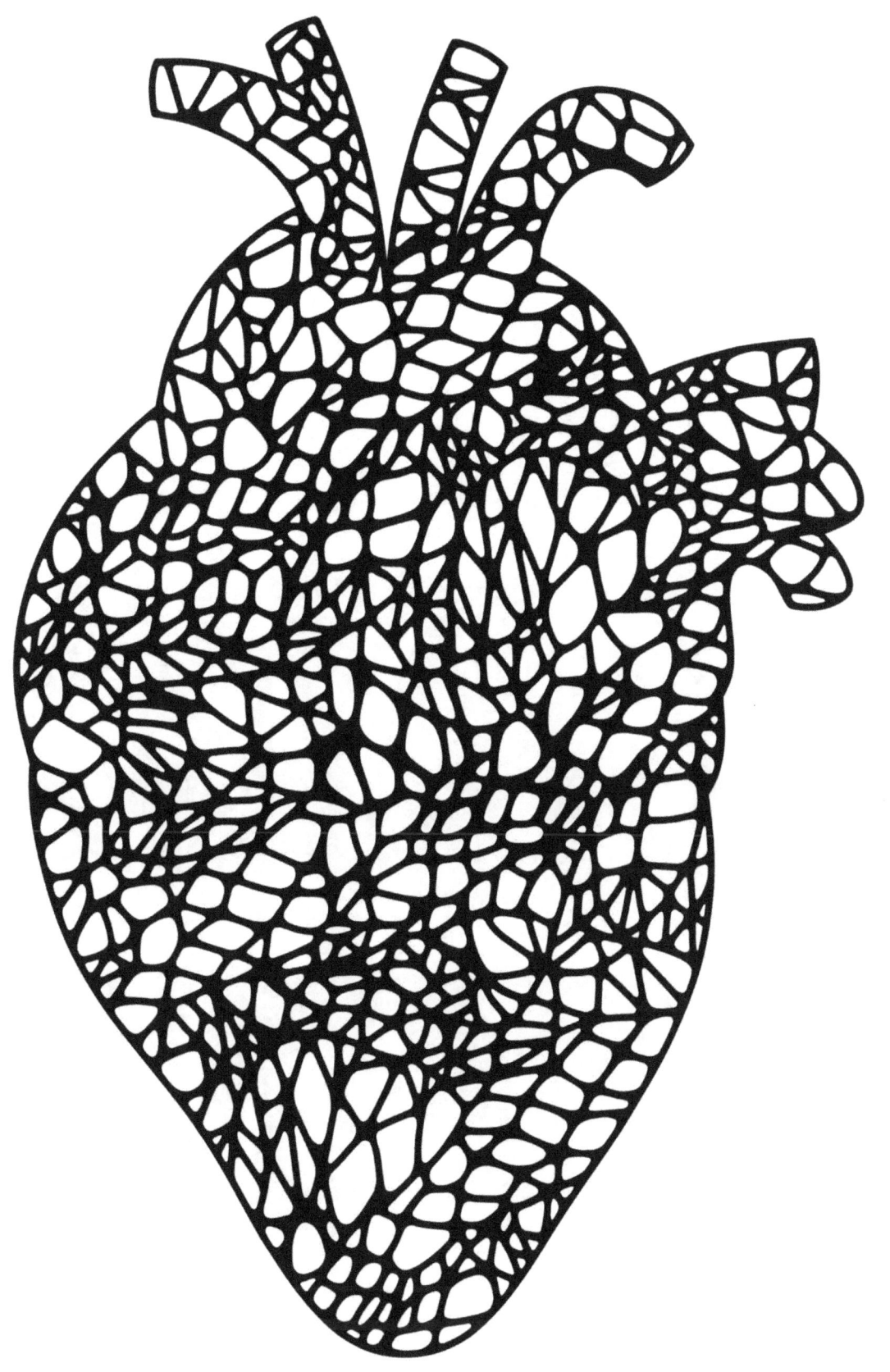

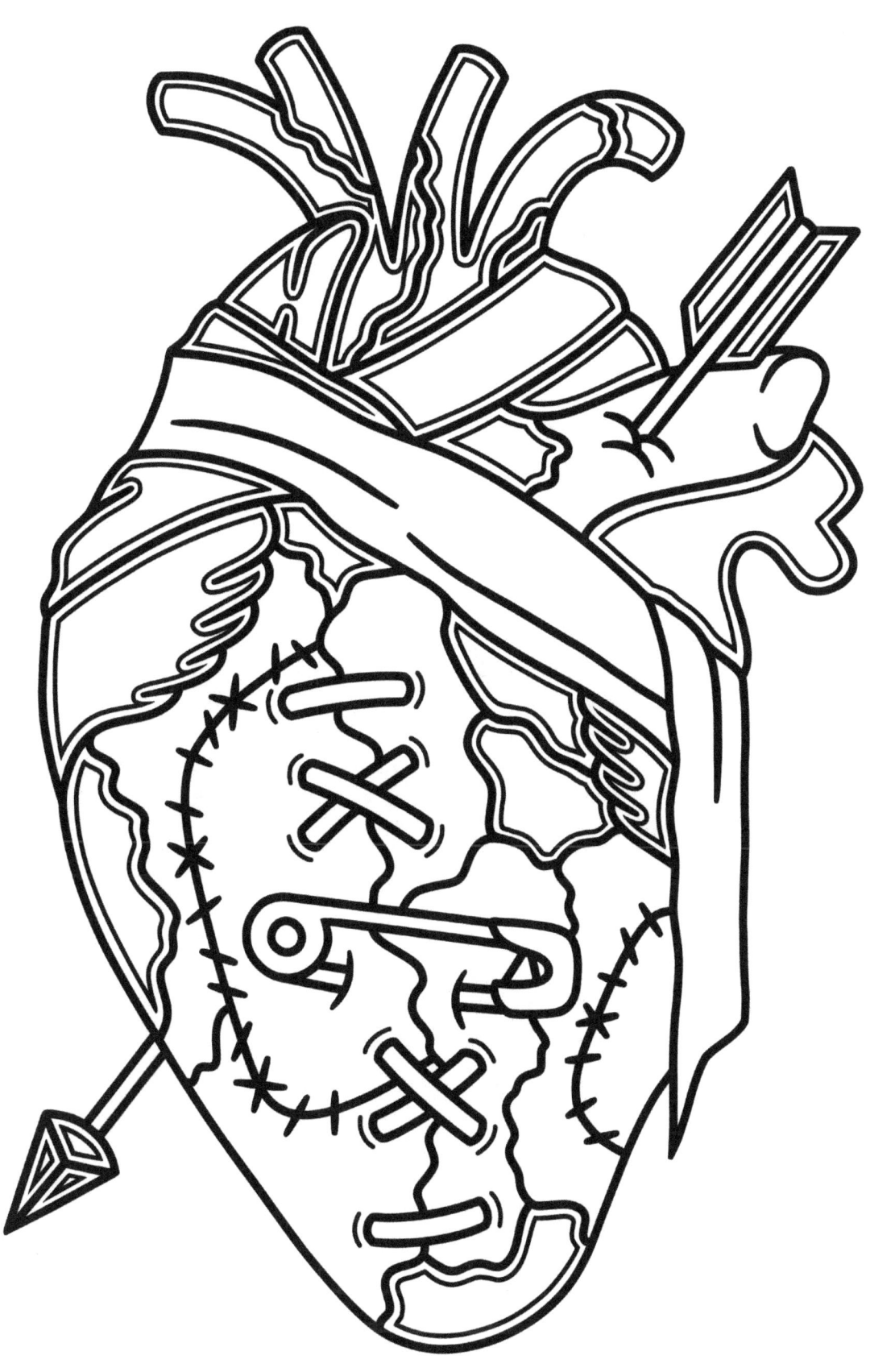

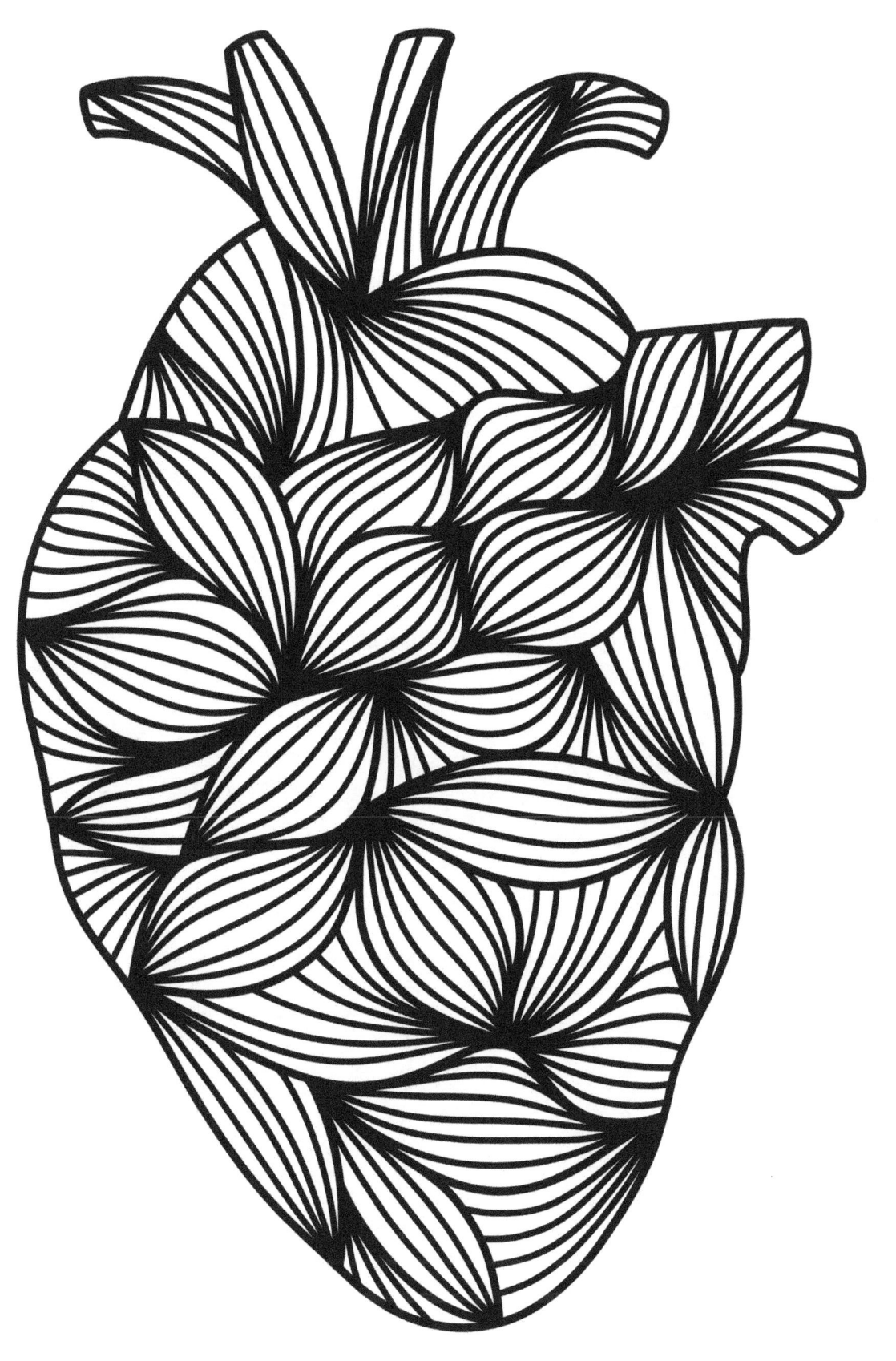

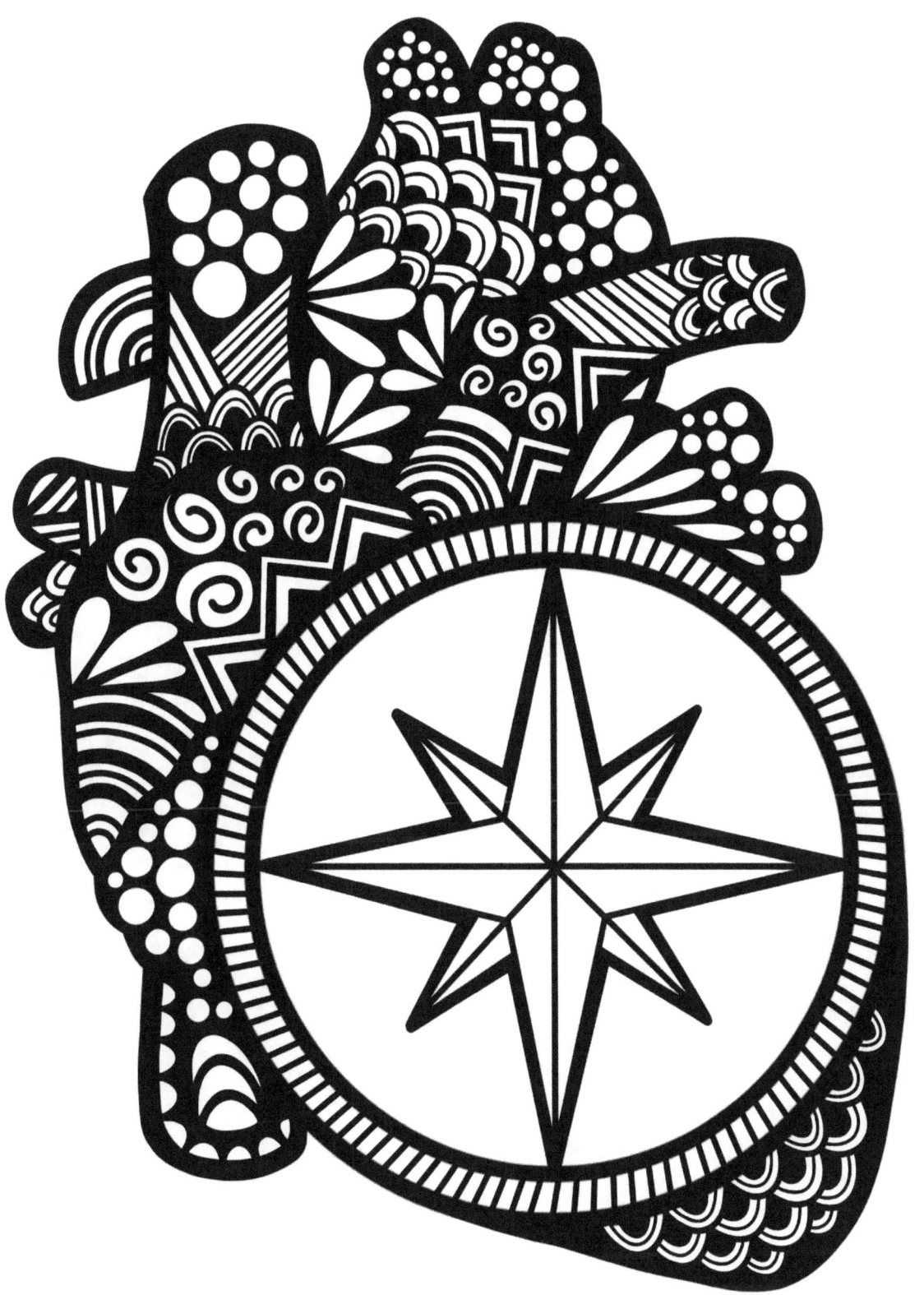

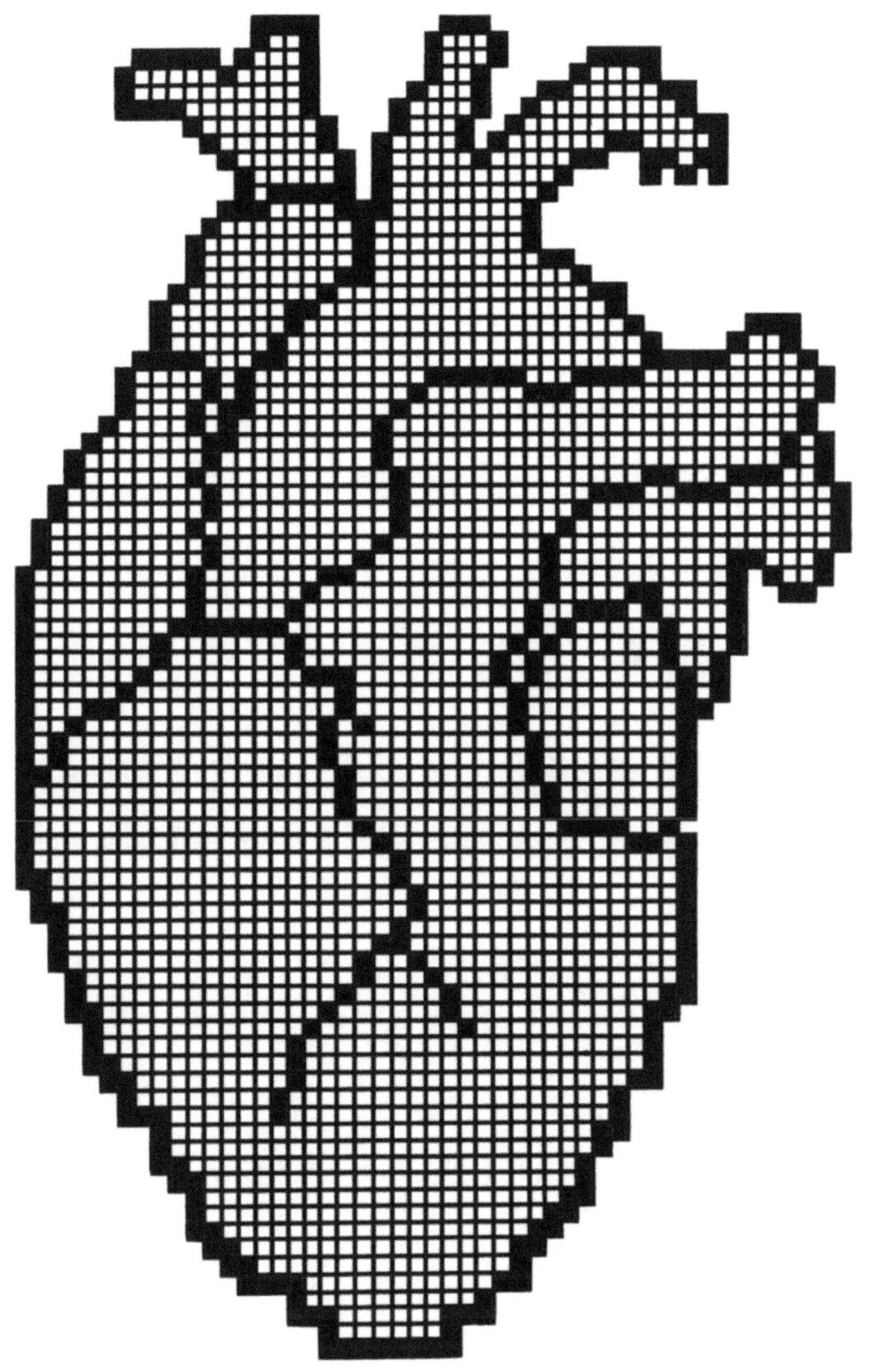

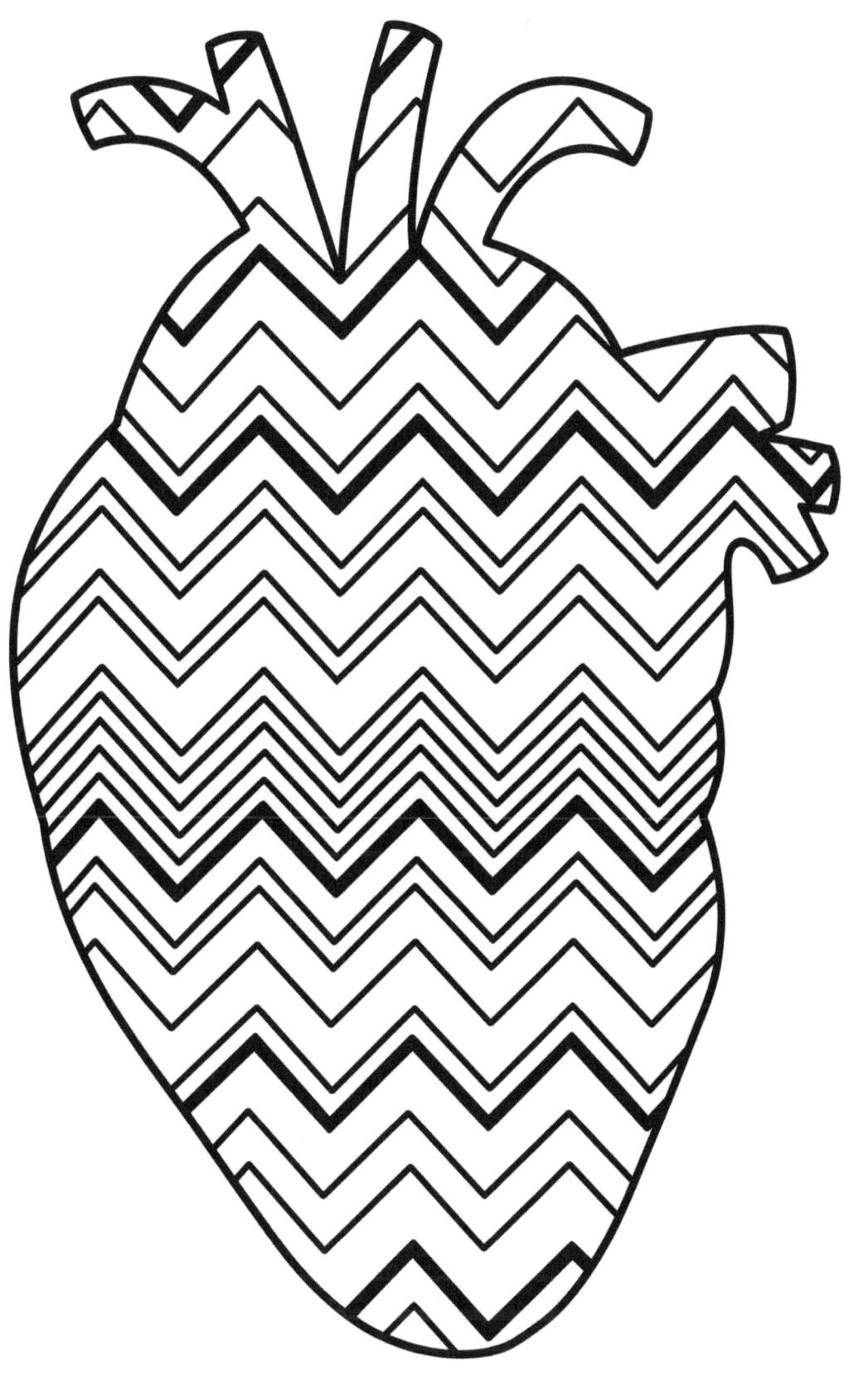

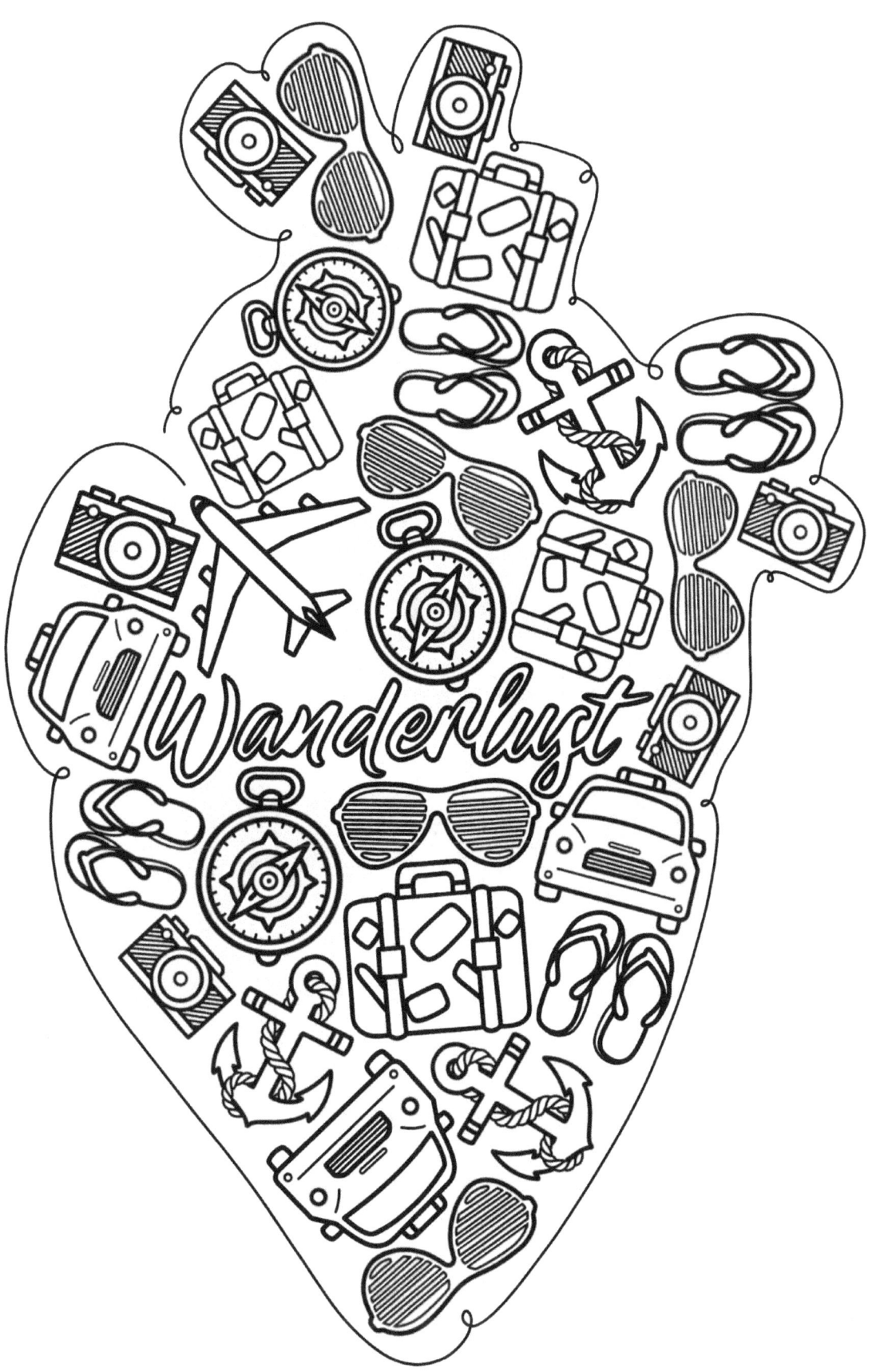

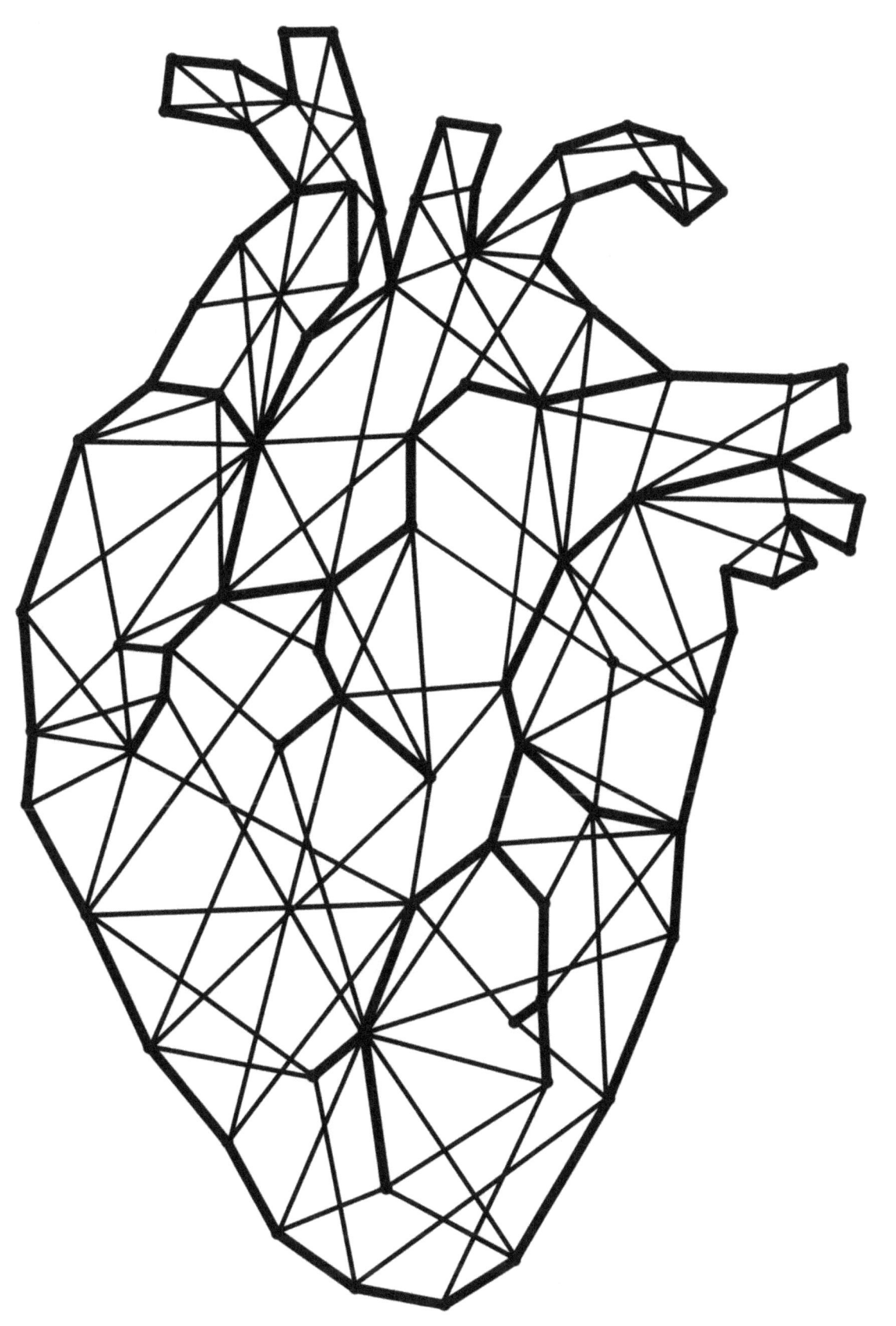

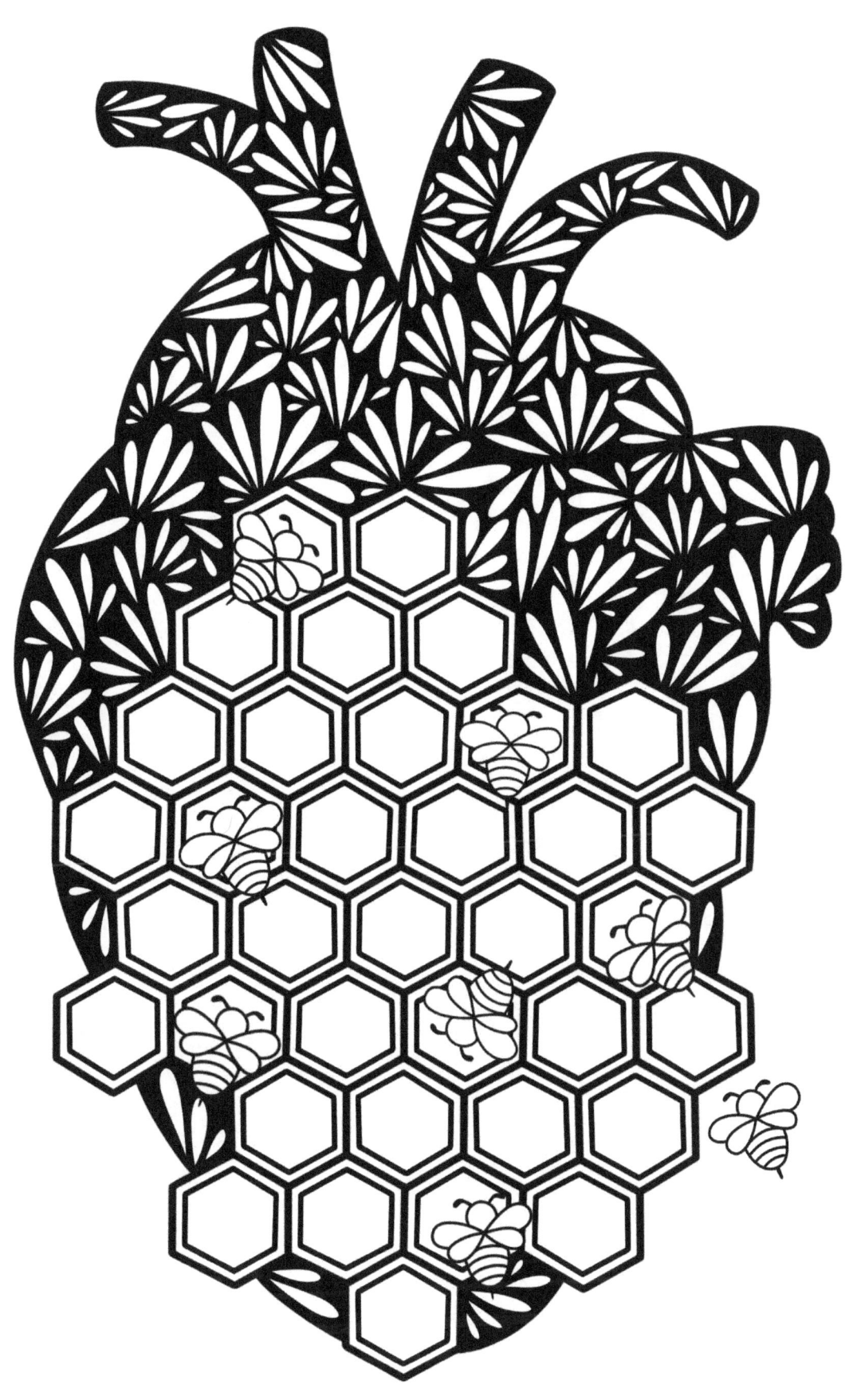

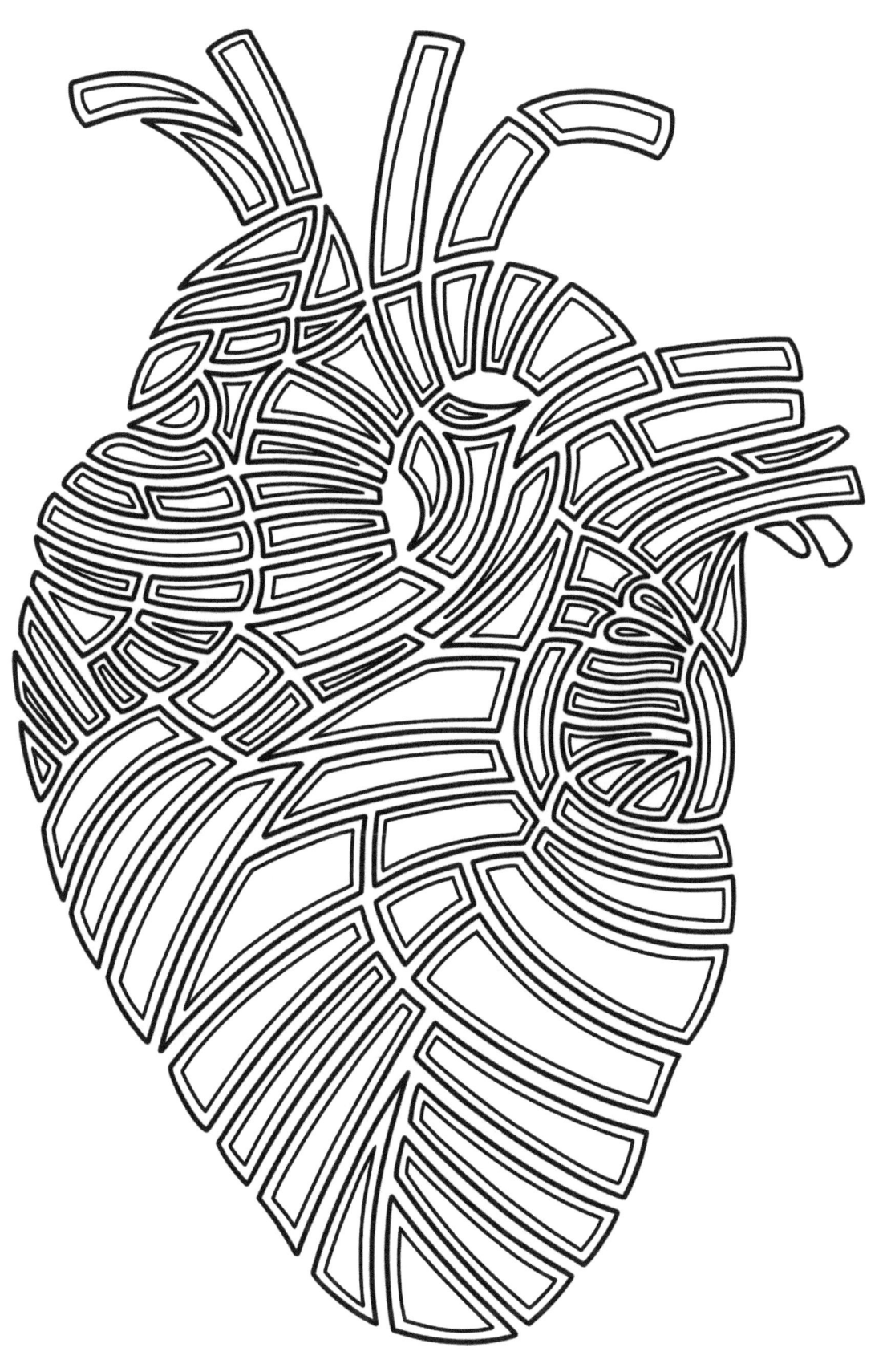

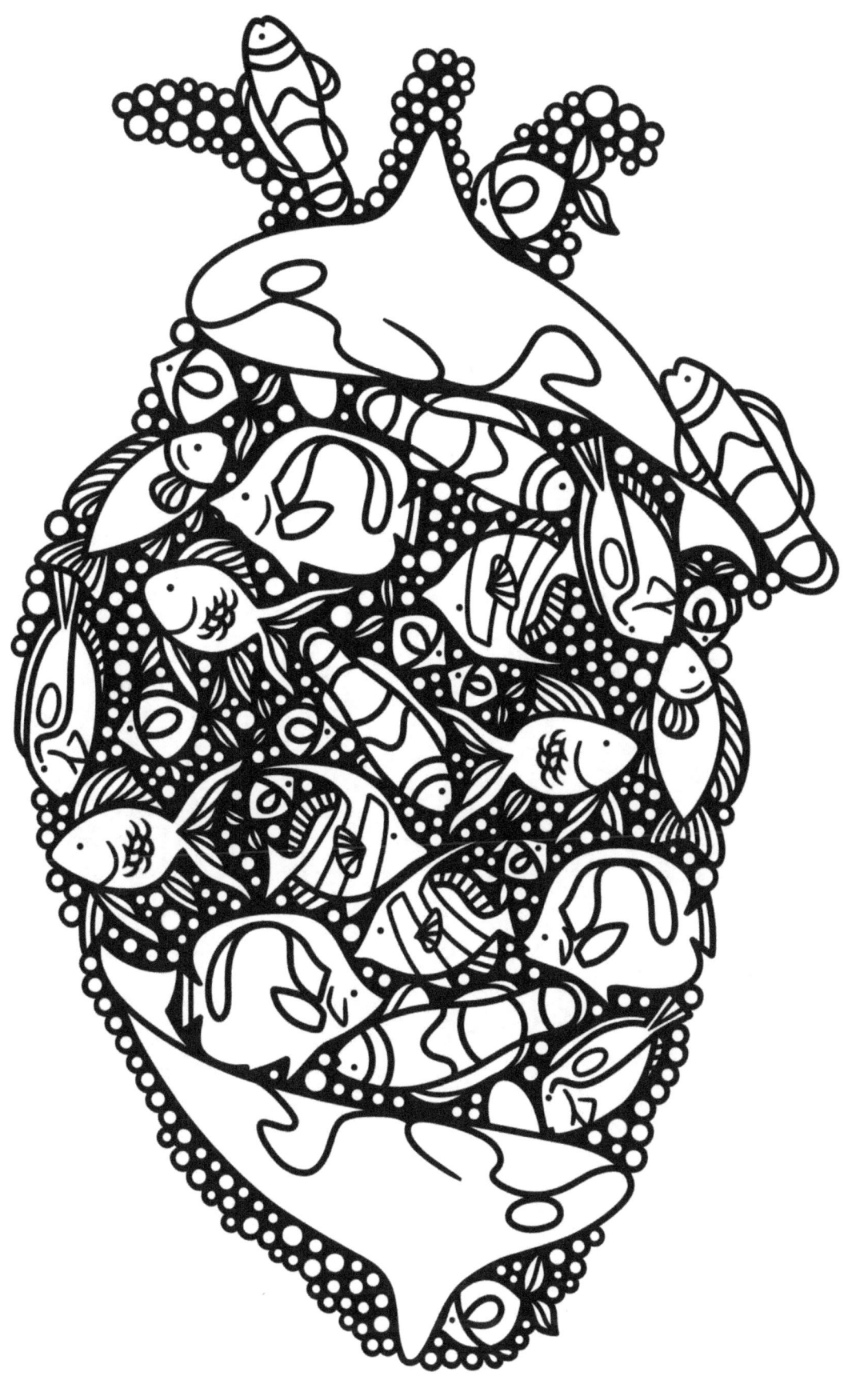

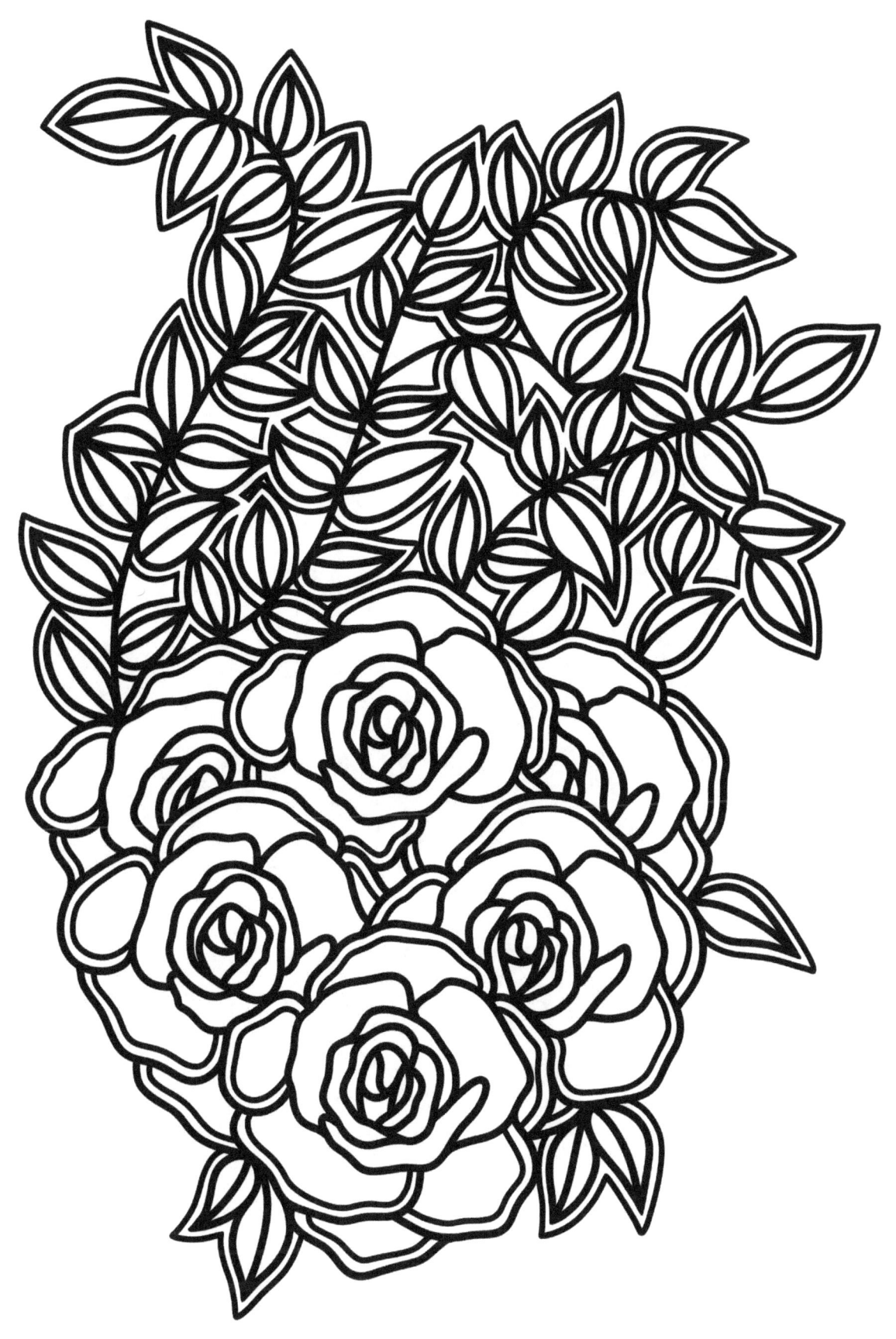

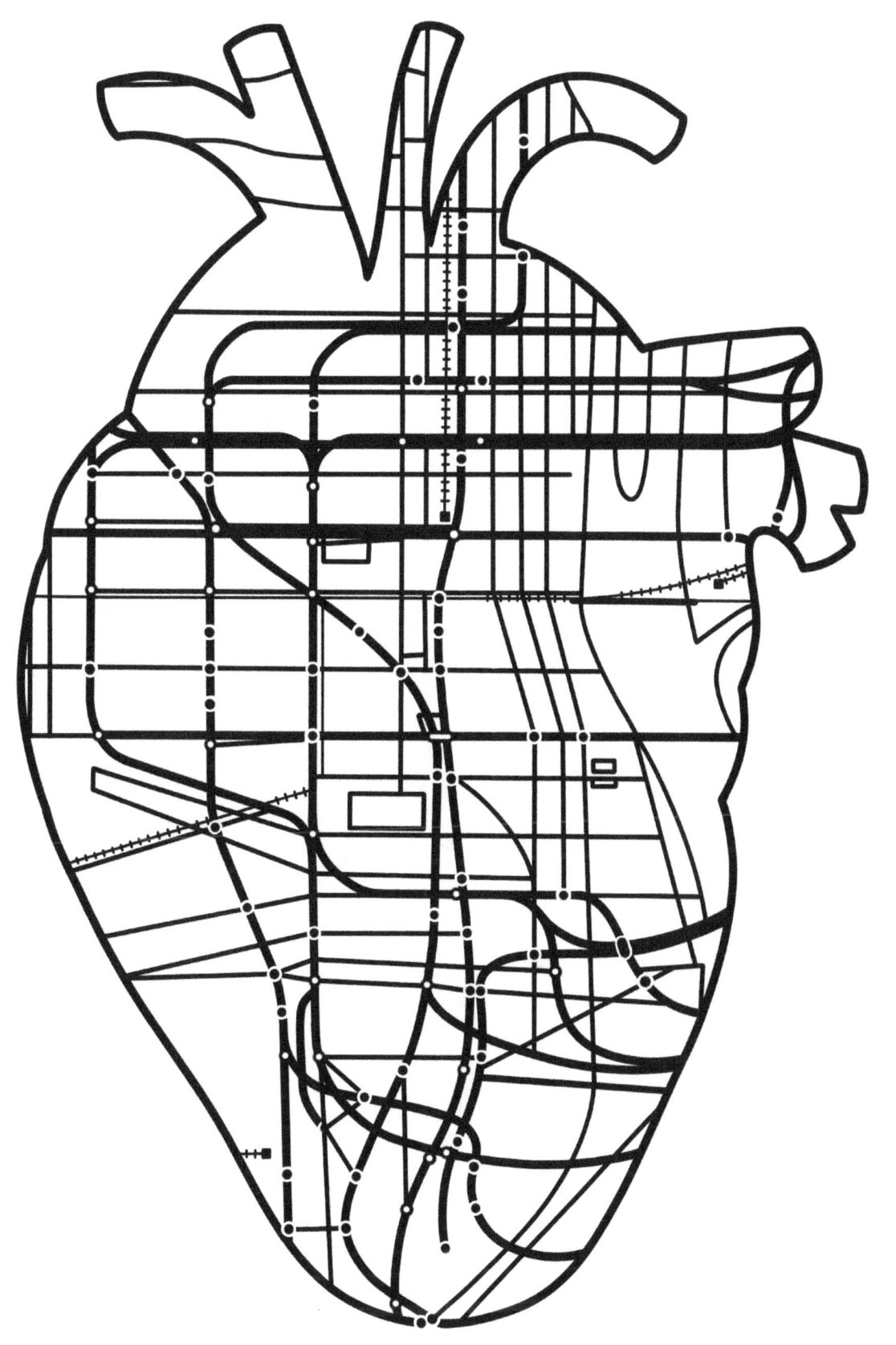

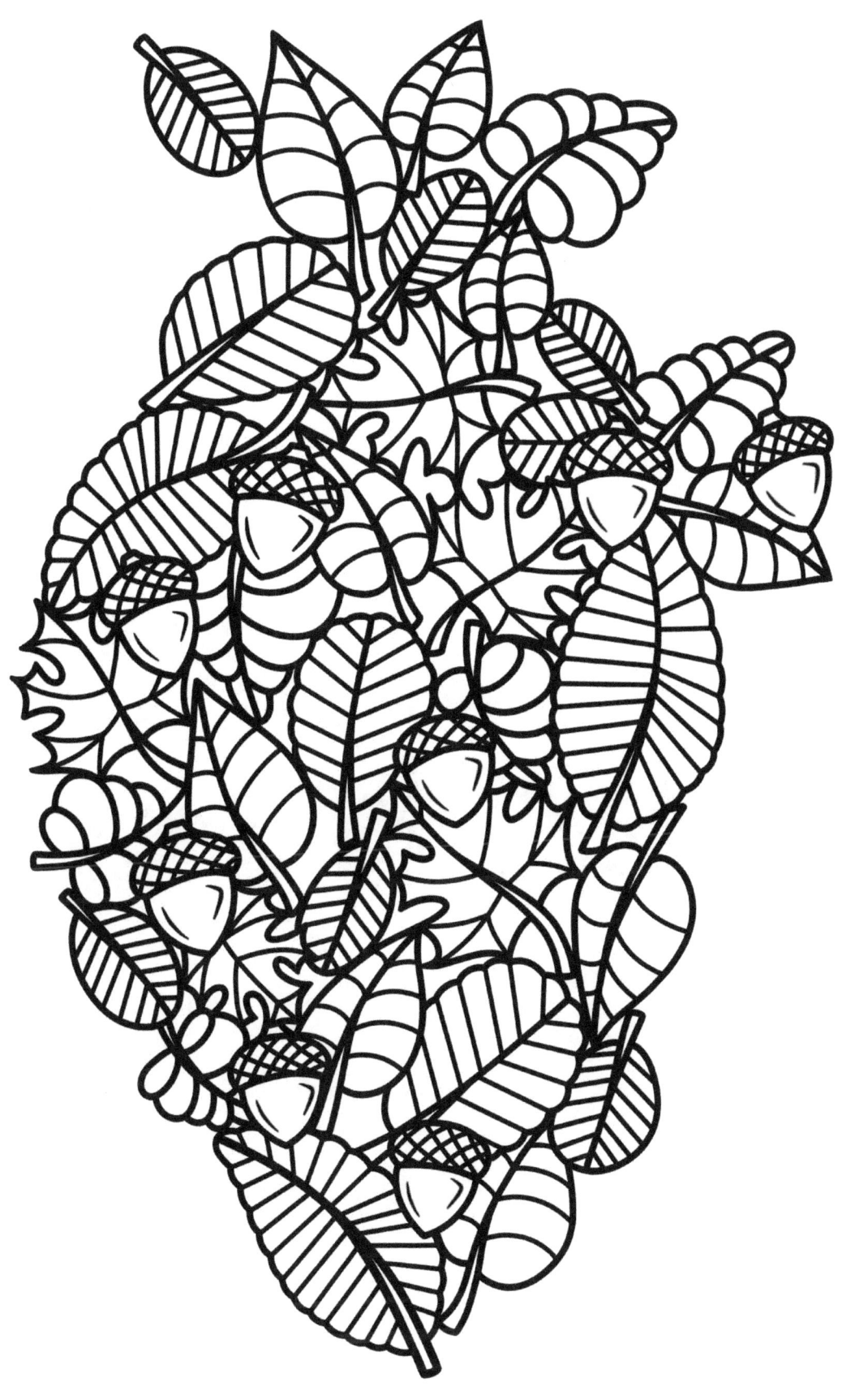

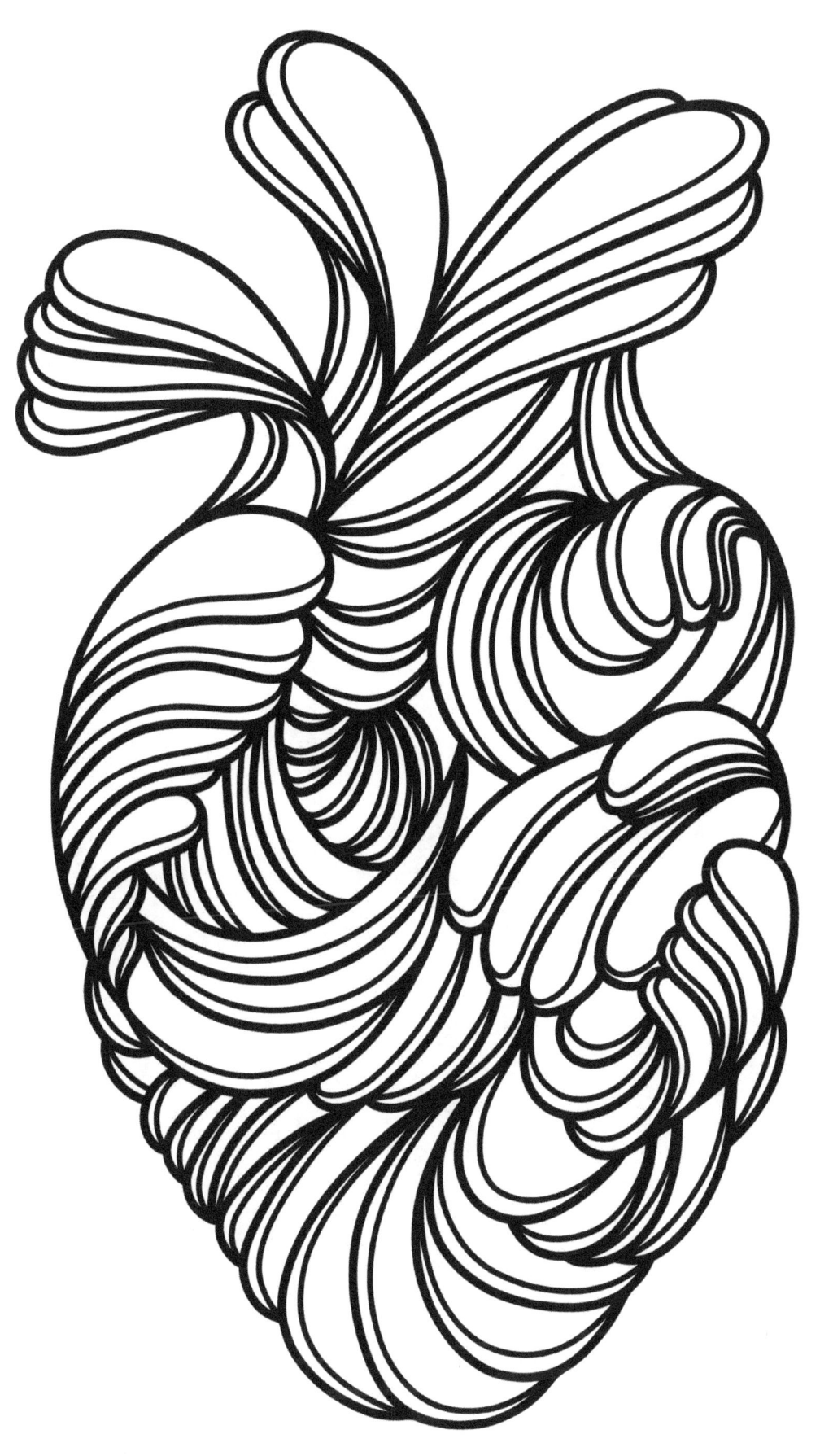

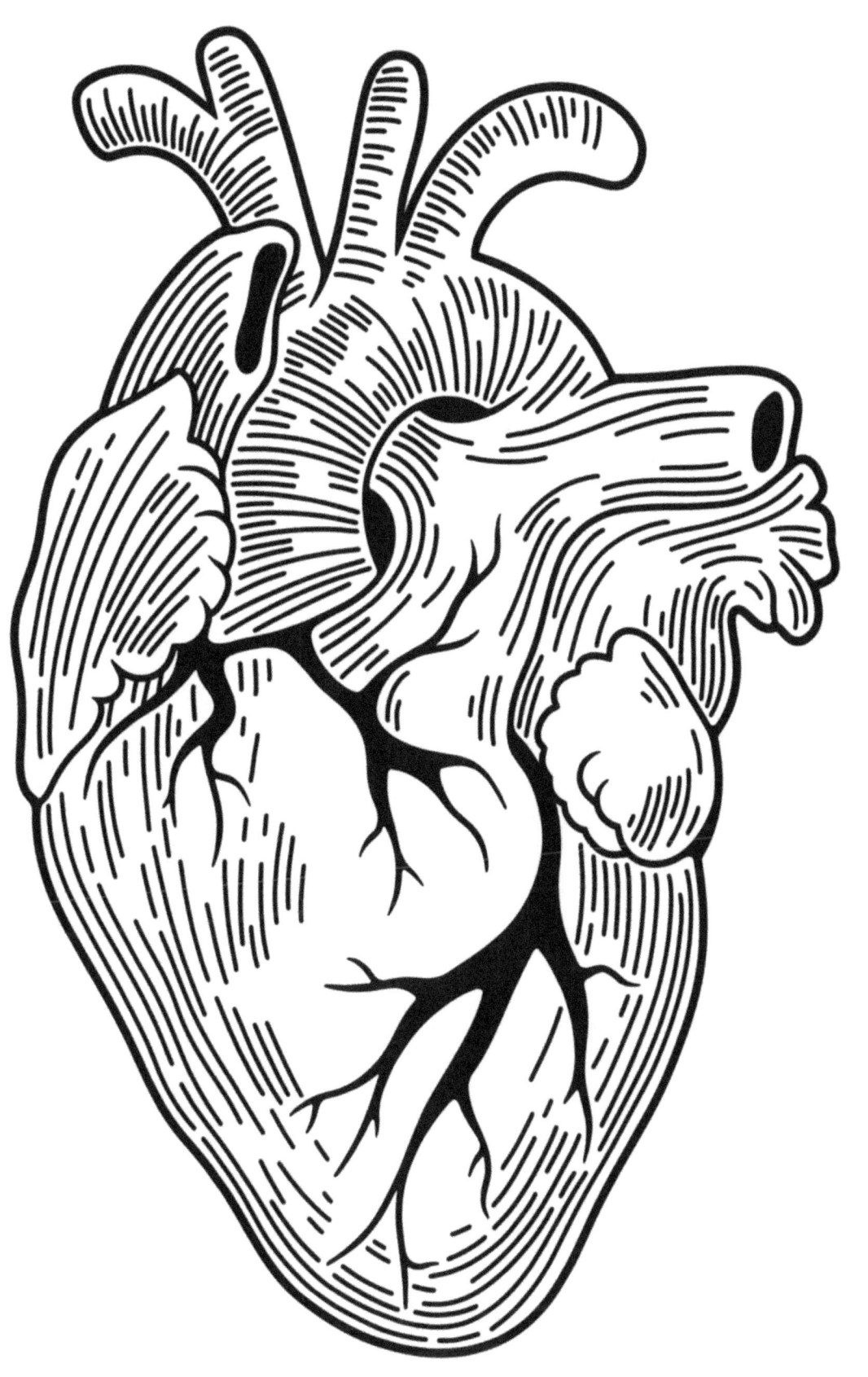

XIXI WANG is a Canadian-American artist. Born in San Francisco, Xixi grew up in Vancouver, British Columbia and currently lives in New York City. She is a student at The Nightingale-Bamford School and will be attending Barnard College starting September 2018. As an artist, Xixi excels in drawing, painting, and graphic design. She has been sharing her work on Instagram (@_artistx) for over four years, hoping to inspire young, aspiring artists like herself. This is her first book.

ACKNOWLEDGEMENTS

I would like to thank Panayotes Dakouras and Maya Popa for their advice and assistance. Thank you to my family and friends at The Nightingale-Bamford School. I will forever appreciate your constant encouragement and belief in me. A special thank you to my forty-three Kickstarter backers. This book would not have been possible without your support.

www.ingramcontent.com/pod-product-compliance
Lightning Source LLC
Chambersburg PA
CBHW080619190526
45169CB00009B/3238